CULT ARTISTS

CULT ARTISTS

50 Cutting-Edge Creatives You Need to Know

ANA FINEL HONIGMAN

WHITE LION
PUBLISHING

CONTENTS

INTRODUCTION

——

According to Paul Gaugin, art is either 'revolution or plagiarism'. The fifty iconoclasts presented in this book deploy art as revolution. Their work spans centuries, mediums, subjects and audiences but shares a radical sensibility. Each of them introduces a singular vision that speaks to broad philosophic, social and ethical concerns. They borrowed and built from each other while creating unique and deeply disruptive work that continues to challenge and change our collective understanding of art, society and ourselves.

The word 'cult' can denote a strictly niche identity, isolated to subcultural significance, or indicate a person whose powerful vision evokes veneration. Some of the artists in this survey have intense underground followings who adore them for beliefs and aesthetics too chewy for mainstream appreciation, but others are iconic for permanently altering the mainstream. Basquiat (see page 14), for example, remains a cult figure despite his 'art star' place among the highest-selling artists in historic auctions because the intensity and integrity of his vision typifies an evergreen renegade sensibility. Similarly, Salvador Dalí (see page 43) has a massive cultural footprint while his surrealist imagery continues to influence emerging artists. Frida Kahlo (see page 74) holds an almost deified status for artists, especially female artists, who attribute healing properties to her intimate self-portraits. The broad appeal of these canonised artists' work makes them into gurus, ushering followers from all levels of cultural literacy and interest into more emotionally invested relationships with art.

The deep subculture significance instead of establishment support for many of the artists in this book highlights systemic prejudices in mainstream culture and the

problematic perimeters of the art world. For these artists, 'cult' status can mean that they create from within communities traditionally overlooked by art insiders. For instance, Dan Attoe's (see page 11) paintings and drawings speak for the profound values, mythologies and struggles of Americans marginalised in contemporary art. Faith Ringgold's quilts (see page 114) tell captivating stories about art's barriers and art's paradoxical magic ability to transcend societal constraints; and Nan Goldin's early imagery (see page 65) celebrates the life-affirming creativity of people struggling for survival on society's peripheries.

Similarly, Molly Crabapple (see page 38) proudly positions her insurgent art as a banner against the conventions and culture of the contemporary art world, crowd funding her work from countless supporters instead of selling to big-budget collectors. Her self-defined identity as an artist for the people is evidenced by her role in the Occupy Wall Street movement, where her art was the visual signifier for a movement threatening capitalism and elitist structures, and claimed an expansive following who felt neglected or belittled by elite art institutions.

In a world where women artists are still under-represented in galleries and paid less than their male counterparts, this survey weighs heavily towards ground-breaking feminist perspectives. The histories of collective support and sisterhood in waves of feminist creativity and activism show that feminist artists often empower their cult followings to become creative agents. Judy Chicago (see page 35) and Barbara Kruger (see page 88) represent strikingly different aesthetics and interpretations of feminist identities but both have shaped how generations of women view their bodies, societies and themselves. Dorothy Iannone (see page 70) and Sophie Calle (see page 31) demonstrate the feminist adage

that 'the personal is political', turning their loves, erotic adventures and fascinations into templates to validate other women's inner lives. For these artists, cult status enables them to nurture social action and all women's self-affirming expression.

The activist orientation that Crabapple embodies is one of the strongest unifying factors tying together the artists across eras, mediums, nations and identities. The majority of artists presented here created art to fight against systems of social injustice. As Basquiat's former girlfriend wrote in her biography about him, 'everything Basquiat did was an attack on racism'. His art, career and legacy remain intensely relevant statements about the intricacies of race and racial discourse in our world. Genesis P-Orridge (see page 110) is a pioneer in destabilising and exploding notions of gender distinction, combining an ongoing fight for transgender rights with a philosophical meditation into the nature

of all human connection and desire. Nan Goldin has turned the personal pain she documented in her photographs into fuel for activist actions, changing laws and holding powerful predators to account.

An alchemist's ability to convert pain into progress art is another quality uniting the artists in this survey. Many were shaped by profound traumas, struggled with mental illness, or died in tragic circumstances but managed to transform their direct experiences into expression that resonates and enlightens others. One of art's essential purposes is empathetic, and the personal psychic pain Rothko (see page 117) represents in his colour-fields or Niki de Saint Phalle (see page 44) in her manically exuberant sculptures evokes understanding beyond clinical or even poetic description. Art can compel people to feel another person's inner reality. As Barbara Kruger explained, 'everything I do is trying to create moments of recognition. To try and

denote some feeling and understanding of lived experience.'

Few of the artists in this book act alone. Some, like Gilbert & George (see page 58), seamlessly interwove their romantic and creative lives. Many more socialised together or collaborated, creating networks and bonds between them that make this book more like a map of relationships than a list of isolated creative innovators. Even Joseph Cornell (see page 36), whose personal mythology often portrays him as a recluse because he radically limited his social life, had a friendship with Yayoi Kusama (see page 90) that infused their lives with reciprocal inspiration. Some of the artists shunned art schools and well-marked paths to recognition but forged bonds based on mutual respect and discourse with their fellow creators. These bands of outsiders gathered in New York, London and Berlin during periods in

these cities' histories where cheap rents, unregulated social systems and progressive reputations made them nexuses for artistic adventurers. Hidden in this book is a story of friendships and love, promoting relationships as the ultimate foundation for progressive creativity. The word 'cult' carries dark connotations because groups led by single narcissistic gurus can suppress followers' individuality and agency. In contrast, these artists understood and embraced the importance of input from others as they developed something earth-shatteringly unique.

DAN ATTOE (1975)

—— POET OF THE PEOPLE

Dan Attoe's art speaks to and for Americans between Los Angeles and New York. Full of pathos and poetry, his magic realist drawings, paintings and neon sculptures represent rural America's deeper truths. Alongside his own art-making practice, Attoe heads a group of fellow artists beyond core art-market cities whose bawdy, joyful, shamanistic annual collaborations are cult events in Middle America. Attoe's profound understanding of his natural and cultural environment, and his intricate self-awareness, make him a cult figure among international art-world insiders and outsider artists in America.

Attoe's art explores people's struggles to find meaning and significance with the awareness that their lives are small and fragile. Sexy country girls, burly beasts, bewildered men and other archetypes populate his paintings and neon but America's natural splendour is the main protagonist of his oeuvre. He lives and works in Washington State. His father was a park ranger and he was raised with an intimate connection to nature. His people and their dramas are dwarfed by light-infused landscapes and oceans. In Attoe's majestic and haunting paintings, he adds slender bits of text that deepen, instead of dispel, the mysteries of his characters' lives and psychologies. The writing in his paintings and drawings have the haunting brilliance of Bruce Springsteen or Kris Kristofferson

lyrics. These witty, despairing or insightful sentences usually demonstrate his figures' isolation and alienation.

Attoe's paintings and sculptures evolve from his daily 'Accretion drawings', sketches that he produces for his private exploration and inspiration. Mythic and mysterious, these drawings function as visual haikus, flush with humour, sexuality and sinister undercurrents. Like the paintings that some become, Attoe's drawings are compelling for their uncanniness and mystery.

Counter-balancing the isolation depicted in his solo practice is Attoe's role as founder and leader of Paintallica, an artist collective that he started as a student at the University of Iowa – meeting annually to create massive, sprawling installations at the Iowa State Fair, Portland State University, and Chicago's Western Editions gallery. According to the group, which includes artists Jesse Albrecht, David Dunlap and Jeremy Tinder, its 'realm is a mixture of taboo, mundane, clumsy, deft and absurd... Paintallica's goal is to make ambitious art while remaining honest to our blue-collar flyover state roots and our healthy disdain for New York-centric corporate and academic influences.' In his independent art and work with Paintallica, Attoe has become a leading figure representing America's quiet complexity, overlooked nobility and hidden magic.

BALTHUS (1908-2001)

—— CONTROVERSIAL GENIUS

Balthus famously deplored art criticism or any interpretation of his work. He ardently, and impossibly, insisted that his art be seen independent of him, yet the man who created problematically seductive portraits of prepubescent girls has a captivatingly compelling mythos matching the controversy-laden history of his art. Balthus's paintings, depicting sadism and graphically erotic visions of young girls, have become more controversial and unsettling over time, although he remains a cult figure for his genius. His dream-like images are haunting for their perversion and darkness, as well as their aesthetic beauty.

What is known about Balthus is that he was born Balthasar Klossowski de Rola to Polish expatriates. He appropriated his childhood nickname as his artistic *nom de guerre*. His father was an admired art historian but his mother's history has several stories. According to some accounts, she was the Russian Jewish daughter of a cantor or a French Protestant or descending from the richest Sephardic Jewish family or, even, a lost Romanov. Regardless, the family became prominent members of Paris's chic intellectual circles and Balthus was raised with Rilke, André Gide and Jean Cocteau visiting his home before his family relocated to Geneva during World War I. When Balthus

was a boy, his mother had an affair with Rilke, who encouraged his artistic talents and exploration.

The first artwork Balthus made public was a graphic novel about a boy's lost cat. A fascination with felines was a reigning thread throughout his art during his own boyhood, through his military service in Morocco, and his eventual relocation back in Paris. Once settled in France, his work developed into the psychologically tormented but bewitching imagery comprising his legend. His 1934 painting *The Guitar Lesson* is among his most famous and infamous. It depicts a young woman holding a prepubescent girl across her lap. A guitar lays at their feet. The woman is pulling the child's hair and her other hand hovers very close to her naked vulva. The girl pulls down the woman's blouse, exposing her pert breast. Both characters' expressions are blank and their bodies are tense. The sadism and horror of molestation is compounded by his figures' nightmarishly transfixed appearance. This sense of mystery and trauma is heightened in his 1939–1946 painting *The Victim*, which shows a naked girl contorted in crinkled sheets, with the crime unspecified. Like all his work, this image depicts humanity's worst with unnerving beauty and grace.

JEAN-MICHEL BASQUIAT (1960–1988)

—— PERMANENT REBEL

The term 'art star' was coined in the 1980s for Jean-Michel Basquiat. Although he rapidly became the youngest, hottest, most famous and fashionable artist of his era, he retains his 'cult' status because of his influence on New York's underground subcultures. Punk, graffiti, art-house and hip-hop owe as much to Basquiat as the mega-money, gilded, high-art gallery and auction worlds where he still reigns, even decades after his death at age twenty-seven.

Long before Basquiat's 1982 untitled painting sold for a record-breaking $110.5 million at auction, he altered the spirit of Manhattan's ravished streets with his graffiti poetry. Writing poetry on walls using the tag SAMO© (standing for 'Same Old Shit', according to street art lore), Basquiat's provocative spirit became his artistic signature. He kept this raw, vivid and confrontational energy when he moved to massive figurative, oil on canvas, paintings.

As SAMO©, Basquiat criticised capitalism, religion, art, racism, social pretention and himself. These themes remained dominant in his intensely powerful paintings.

Lust for a Cinderella story shaped the art world and mainstream media's perception of Basquiat's history and his art. He was championed as a literal rags-to-riches story. However, while Basquiat was homeless and adrift before breaking into the city's rarefied gallery scene, he was not raised in poverty. His father was a successful accountant and sent his son to a school for gifted, artistic children. Half Haitian and half Puerto Rican, he was raised trilingual. Although he never attended art school, Basquiat was highly literate in art history and broadly knowledgeable. His art is infused with sincere and sarcastic references to theological traditions, literature, anatomy and his deep love of jazz.

Although Basquiat was intensely open in his art and interviews about his experiences

> **" I DON'T LISTEN TO WHAT ART CRITICS SAY. I DON'T KNOW ANYBODY WHO NEEDS A CRITIC TO FIND OUT WHAT ART IS. "**

with racism, he was more guarded about his addictions and mental health struggles. Mental illness brought him from his comfortable childhood context to park benches, then a cardboard box, in New York's infamous Tompkins Square Park when he was fifteen. His mother was institutionalised and his father was abusive. He ran away from home after dropping out of school. On the streets, he found a renegade community. During the seven years when he was scaling the heights of global art-world fame, before his fatal heroin overdose, he collaborated with David Bowie, Blondie and Comme des Garcons but mostly Andy Warhol. He also dated Madonna and appeared on the cover of the *New York Times* magazine in a paint-splattered Armani suit.

Cynical and critical, but funny and magnetic, Basquiat was known as difficult. His addictions shaped his behaviour and character. The feverish energy evident in canvases like *Untitled (Fallen Angel), Red*

Rabbit or *Ernok* demonstrated the frenetic power of stimulants or mania, as well as his signature talents and aesthetic. His rages became legend in the art scene and gossip press but his warmth and vulnerability remain precious to people who knew him.

In 1996, his former art-world compatriot, Julian Schnabel, directed a biographical film of his life starring David Bowie, Dennis Hopper and Gary Oldman. This beautiful portrait dramatised the ferocious combination of vulnerability and cynicism, openness, manipulation and passion with disdain evident in his art. His art's feral passion is forever shocking.

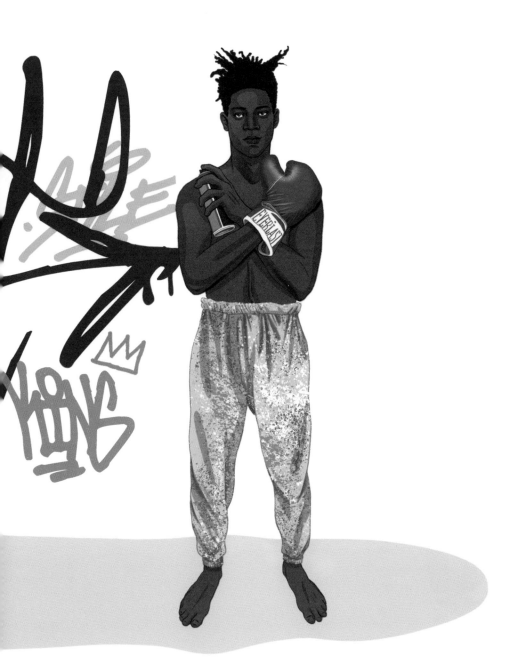

JOSEPH BEUYS (1921–1986)

—— SPIRITUAL GURU

Joseph Beuys is an artist whose cult status borders on being cult-like. His followers regarded him as a shaman and guru. He is widely regarded as a seminal figure in 20th-century art for his spiritual, humanist, gnomic art. Beuys perceived and promoted art as Richard Wagner's notion of '*Gesamtkunstwerk*' or an all-encompassing, total, universal artwork. His performances and sculptures aspired to represent art interwoven with reality.

The core of Beuys's work was wrangling with his history, alongside all his countrymen, in the Hitler Youth and his experiences when his military plane crashed in the Crimea. According to Beuys, his broken body was salvaged by nomadic Tatar tribesmen who wrapped him in animal fat and felt, saving him from death by hypothermia. He regained consciousness when insulated by the fat and his episodic memories of resurrection haunt his art. Fat

and felt became his signature mediums alongside everyday objects, like VW vans, sausages and a live coyote.

I like America and America Likes Me, Beuys's 1974 performance piece, involved him living locked in a room with a coyote for three days, in eight-hour shifts. He arrived to the room in a New York gallery, in an ambulance and wrapped in felt. Beuys communicated with his lethal companion and they played tug. For Beuys, the coyote was a symbolic homage to Native America lore, which perceives coyotes as spirits of transformation. He described the work as a 'reckoning' with history that could lift America's trauma. The playful creature seemed to collaborate well with him.

In an early artwork, *How to Explain Pictures to a Dead Hare* (1964), Beuys walked through an art gallery while cradling a dead hare in his arms. His face was covered in honey and gold leaf. He mumbled,

conspiratorially, to the corpse. When viewers were allowed into the space, he sat on a stool, still cradling the dead creature, and stared blankly at them. He deemed the hare a symbol of incarnation and interpreted his unnerving mask as paganistic symbols of rebirth. By keeping the art's meaning secret between himself and the pre-reincarnated animal, Beuys was privileging mystery over intellectualisation.

The layers of natural symbolism, bringing death and danger intimately close to rebirth and hope, captivated Beuys's accolades. Alongside his art, Beuys was a tireless teacher and lecturer. He claimed that teaching was his 'greatest work of art', while his art was fundamentally a form of teaching.

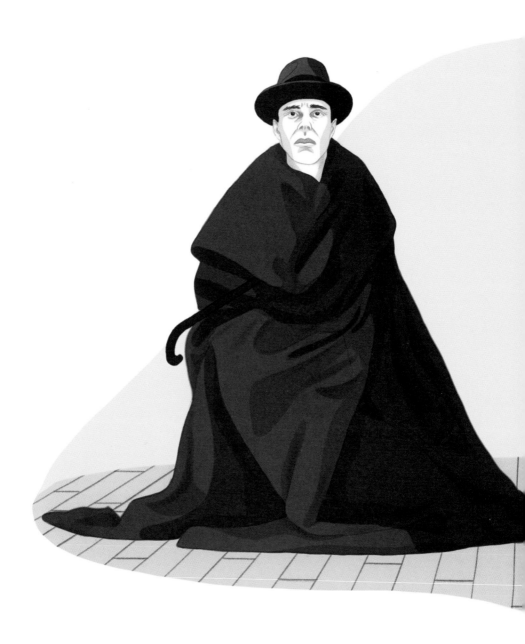

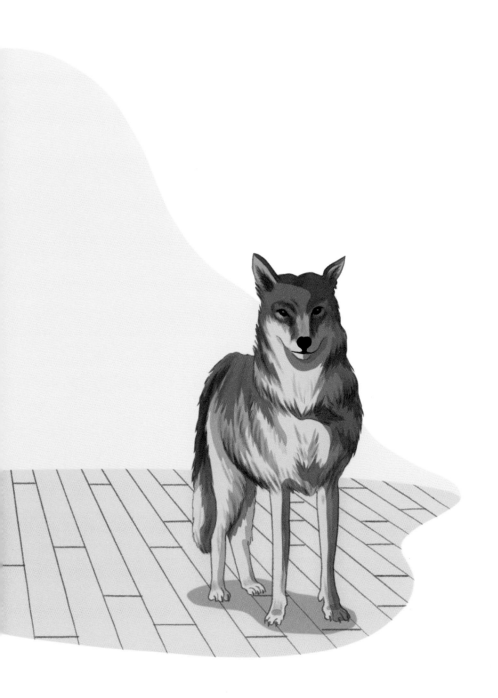

CHRISTIAN BOLTANSKI (1944)

—— HISTORY'S WITNESS

Christian Boltanski's art is haunted by the horrors of his early childhood, when France was liberated from Nazi occupation. Throughout his life, he has become a leading barer of memory, carrying the weight of history into the present and eloquently compelling his audiences to constantly view historic and contemporary atrocities with fresh eyes. His work often centres on the everlasting pain of the Holocaust while also becoming universal. As he describes, 'my work is about the fact of death, it is not about the Holocaust itself'.

Boltanski's art is founded upon his awareness of identity and history. His father was a Ukrainian Jew but his mother was Corsican, meaning he is not technically Jewish by strict biblical law but would have been a victim of Nazi murder during the Holocaust. The fortune of his survival and tensions within his personal ethnic identity are constant undercurrents in his work. Boltanski's art speaks with the depth and power of someone who does not take his existence for granted.

According to his lore, Boltanski left school at thirteen and started to create massive expressionistic paintings in the mid-1950s. His paintings received modest attention but films and notebooks examining his childhood, in harrowing imagery, garnered him significant critical attention.

In the 1980s, he created vast installations illuminating photographs of Jewish schoolchildren in Vienna from the 1930s. This brutal memorial, infusing the victims' faces with light, is a defining image of Holocaust remembrance. He revisited these themes of overwhelming loss with a 10-ton pile of discarded clothes, symbolising their 6,000 lost or dead former owners.

In the late 1990s, Boltanski invited children at the Lycée Français de Chicago to bring him their favourite toys. He then created classic black-and-white portraits of each cherished possession for his celebrated *Favorite Objects* series. These noble images of Transformer toys and ratty stuffed bears turn today's mundane objects into historical artefacts, assuming a premature nostalgia, and demonstrate Boltanski's life-long fixation with lost childhood. The series also proves his famous sweetness and warmth. For an artist who has won countless awards, and is considered one of France's most significant artists with a cult following among scholars, other artists and Europeans wrangling with the responsibilities of being ethical in a contemporary global context, Boltanski is also known for his humility and kindness. His art promotes remembrance in the hope that humanity will become humane.

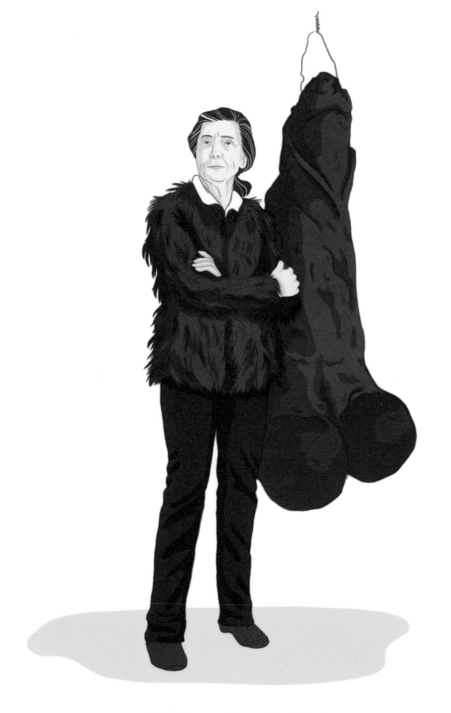

LOUISE BOURGEOIS (1911–2010)

—— FEMINIST INNOVATOR

A photograph taken in 1982 of Louise Bourgeois by Robert Mapplethorpe might be the best description of the 20th-century's most influential, innovative and everlasting female sculptor. In the black-and-white portrait, Bourgeois is seventy-one and proudly looks her age. She wears a black monkey fur coat and no apparent make-up. She smiles with evident glee and wisdom. Tucked under her arm is *Fillete* ('little girl'), a black latex-covered plaster sculpture of a massive penis and testicles. Bourgeois's expression is cheeky and victorious. This image, which quickly became iconic, is proof of how and why she retains cult status among feminists, artists, late bloomers, Lacanians and anyone looking for inspiration on turning trauma into triumph. Dark and dirty, her work gives voice to women's sexuality in all its complexity.

Mapplethorpe's portrait was taken the year Bourgeois had a retrospective at New York's Museum of Modern Art and revealed in an interview that all her work was autobiographical. Before contextualising her art with the statement 'everything I do is inspired by my early childhood', her work was dismissed for its strangeness. The specific event Bourgeois endlessly replays was her tyrannical father's affair with her English tutor, when she was eleven, evoking her everlasting Electra complex.

Bourgeois openly addressed how her constant, violent, almost obsessive, phallic imagery was a fruitless attempt to explore her fixation with her father's sexuality and her parents' marriage. *Spiders*, like her 9-metre one titled *Maman,* from the 1990s, were her symbol for mothers, while the penises belonged to her father. Alongside these two principal symbols, female nudes and disembodied hands were regular features in her disarming oeuvre. Bourgeois's repetition of imagery evoked her love of maths, which she studied at the Sorbonne. 'I got peace,' she said, 'only in the study of rules nobody could change.' In her art, she created a similar sense of consistency and structure, despite the apparent horrors and sadism she depicted.

Although Bourgeois's work, full of severed members and room-sized spiders, was frightening, the impish smile she showed Mapplethorpe represented her personality. She was widely beloved by her fellow artists for her wit and open spirit. She held feminist salons in her home called 'Sunday, bloody Sunday' and formed activist groups fighting against censorship and for LGBTQ rights. Although she endlessly worked through her specific history in her art, her rebelliousness and relentless self-searching resonates with generations of admirers.

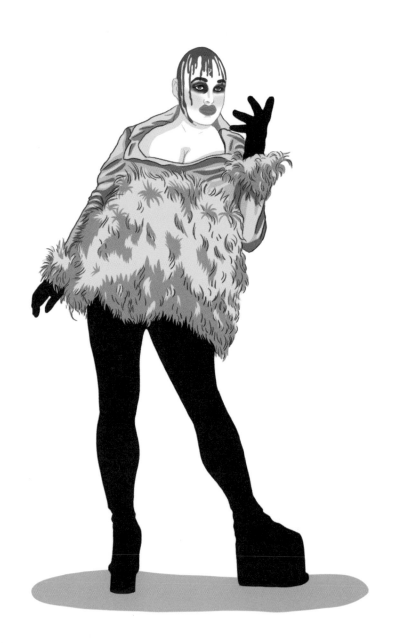

LEIGH BOWERY (1961–1994)

—— BOUNDARY-BREAKING MAVERICK

Leigh Bowery made London's nightclubs into the 1980s' and 90s' most avant-garde art forums. Whether simulating himself giving bloody birth to his petite, nude wife at the elite Anthony D'Offay Gallery, posing in bare flesh for Lucian Freud, or promoting the aptly named Taboo club, Bowery fused grotesquery and beauty into an electrifying mess. He shattered boundaries to become a perennial for artists, fashion designers, musicians and all creative outcasts. As a pansexual pioneer, his art celebrated pleasure. His cult following contains fellow agent provocateurs from Lady Gaga, David Bowie and Alexander McQueen to Matthew Barney, Paul McCarthy, Mike Kelley and Ryan Trecartin.

Bowery was born in Sunshine, Australia before moving to London to join the New Romantic club scene. He quickly became nightlife's leading dissident figure and a creative trailblazer. Although he primarily identified himself as a fashion designer, showing at London Fashion Week and presenting work in New York and Tokyo, his garments were closer to one-off fabric sculptures constructed specifically for his astonishing physique and persona. Bowery often exaggerated his 6-foot 3-inch height with platforms or heels and amplified his weight with costumes, to create otherworldly creations. He was a large man who appeared disarmingly nimble

and light in his ethereal costumes. Like Genesis P-Orridge (see page 110), gender was a primary subject of Bowery's masterful machinations. He dressed as a demonic Mary Poppins or giant melting, feathered lime. He manipulated his impressive flesh in ways Lucian Freud described as 'amazingly aware and amazingly abandoned'. Vulgarity and abjection were Bowery's regular themes. He harnessed shock value with performances where he cast himself as a giant turd emerging from a toilet or donned excruciatingly constrictive corsets and gaffer-taped cleavage. His signature look was smeared red lipstick, pushing the perimeters of his mouth to horrifically clown-like proportions, and a melting comb-over descending over his powdered face.

As one of the many invaluable artists and creative people to tragically die of AIDS-related illnesses, Bowery passed away in 1994. His legacy remains vibrant. He transcended boundaries between creative genres, merging fashion and art with music and dance. Beyond being a polyglot, Bowery mashed dividing lines between art forms to turn London's underground into a site of socially challenging creativity. As a figure who Mick Jagger once dismissed as a 'freak', Bowery became a muse and maker whose great contribution to visual culture was combining horror, humour and jaw-dropping beauty.

CHRIS BURDEN (1946–2015)

—— PERFORMANCE PIONEER

Chris Burden is the artist who shot himself in the arm for his art. For Burden, danger and potential pain were meaningful sacrifices that artists made to push their work beyond safe commentary and simulacrum into the realm of significance. *Shoot*, his 1971 performance piece, involved an assistant shooting his left arm from a 4.8-metre distance. The action, and the sectorial Super-8 film documenting it, is his most iconic work but part of a larger series of performance projects blurring lines between martyrdom, activism, masochism and art. For his suffering, and the powerful sculptural works he produced later into his career, Burden has become a cult figure among transgressive creative people across disciplines and for anyone questioning the meaning of art in contemporary society.

Physical pain, and the transcending lessons it can bring, inspired Burden's entrance into art. When he was twelve, his foot was severely injured in a road accident and emergency surgery was performed with anaesthesia. He, according to his legend, grew fixated on photography and multi-media art during his convalescence. After earning his MFA from the University of California, Irvine, Burden started staging performances where he, as a young man

vulnerable to the draft, put his own bodily wellbeing in danger to demonstrate the atrocity of the Vietnam War and the US government's wanton disregard for life. In a tragically prophetic statement, he said, 'I had an intuitive sense that being shot is as American as apple pie.' In his 1971 *Five Day Locker Piece,* he enclosed himself in a school locker with only a 5-gallon bottle of water to drink and a twin bottle for his urine. For *Trans-fixed* (1974), he crucified himself, having his hands punctured with nails, across the front of a Volkswagen Beetle.

By the early 1980s, Burden had begun creating kinetic sculptures that apparently defied gravity and rationality. He dropped wood beams into wet concrete for *Beam Drop* (1984/2008), and showed at the Tate a moving city of rubber bands, balsa wood, tissues and other everyday items for *When Robots Rule: The Two Minute Airplane Factory* (1998). Even without his own body, Burden's later sculptures represent his willingness to push his curiosity beyond self-protection, convention and reason towards a greater insight into ourselves, our capabilities and the outside world's limitations. In the language of the 60s and 70s, Burden was a 'seeker' and a conscientiousness-changing pioneer.

SOPHIE CALLE (1953)

—— ## ARTISTIC ANTHROPOLOGIST

Sophie Calle exposed the intricacies of strangers', and her own, lives through stylised visuals and brief bits of text. Intimacy was the central subject of her black-and-white series exploring overlooked, suppressed, hidden and denied parts of peoples' lives. Whether documenting the eccentric or banal messes left by guests in a hotel where she worked as a chambermaid for *The Hotel, Room 47* (1981), or recording her experience being abandoned by a lover with a criminal past in Japan, Calle constructs her artworks like a detective. She focuses on revealing details that functioned like potential clues to peoples' lives, troubles and moments of connection or alienation. She retains her cult following among artists, psychologists, avid readers and anyone interested in other people.

Calle never self-identified as an artist. She sees herself as curious and practising 'private games' while using art as her method of expressing her findings. Her nonjudgmental fascination with people's stories fits within her family context. Her father was an oncologist and her mother was a revered book critic in the 1960s. After graduating from the Lycée, she travelled around Asia, North America and Europe. She attended a party in Paris, in the late 70s, where she met a man she called Henri B. She then followed him to Venice, stalking

him using surveillance and presenting the private-detective-like shots in a clean format that became her unchanging signature style.

In the early 1980s, Calle's use of unwilling subjects in her work evoked international controversy when a French magazine invited her to publish transcripts of conversations she had had with friends and acquaintances of someone she'd never met. She found her interviewees in the man's address book, which he lost and she retrieved. She conceived the project as a portrait of the stranger but the subject, ironically a documentary filmmaker, considered it an unethical violation of his privacy. The objectification of the man's private life raised questions about art's ethical limitations, sexist distinctions between male and female artists' creative licences and muses' boundaries. In a later collaboration with the writer Paul Auster, on his novel *Leviathan,* Calle made herself the subject of these questions when she asked the author to construct a character for her to embody, thereby becoming her own object of fascination and mystery. In the era of Instagram, where we publicise our worlds through curated snapshots and commentary, Calle's art can be taken for granted but the unsettling insights she exposes, blurring all boundaries between fact and fiction, remain captivating.

CHAPMAN BROTHERS (1962 (DINOS) 1966 (JAKE))

—— PUCKISH NIHILISTS

When Charles Saatchi's 'Sensation' exhibition toured London, Berlin and New York, different works by the incendiary roster Young British Artists garnered media and audience controversy by striking different cultural nerves. The one constant was shock, horror, delight and awkward laughter at the Chapman Brothers' dystopian garden of children with genitals replacing their facial features. The naked mutant kids, with their page-boy haircuts and penises instead of noses, became international symbols for the irreverent, assaultive punk spirit defining British-born art in the 1990s and early 2000s. The Chapman Brothers' cult reach extended beyond art throughout popular culture, with the brothers earning rock-star status and movie-star earnings.

Jake and Dinos Chapman's puerile anarchist art seemed totally avant-garde but came with a clear pedigree. While studying together at the Royal Academy of Art, they apprenticed with Gilbert & George (see page 58). Although the elder duo used the grotesque to rip open social hypocrisies and prejudices, the Chapman Brothers' art uses nihilism as a powerful weapon to spotlight and challenge apathy. For their series *The Rape of Creativity*, shown in 2003 at Modern Art Oxford, the brothers bought a collection of Goya's ardently anti-war prints *The Disasters of War* and defaced them with cartoon monsters designed to highlight cultural desensitisation to atrocity. These works were named *Insult to Injury*. In 2008, the brothers adorned thirteen authenticated watercolours made by Adolf Hitler with pretty psychedelia, drawing attention to Hitler's horrific creative banality.

The brothers 'othered' Western culture in 2002 by carving a full collection of wood sculptures in the style of African tribal artworks and displaying them with Pitt Rivers' ethnographic style reverence. Instead of depicting deities, these 'Works from the Chapman Family Collection' were idealised artefacts showing Ronald McDonald and creatures cherishing their boxes of French fries. They crucified the face of fast food, Ronald, on weathered wood crosses and used corporate iconography to question our remaining taboos. Beyond poking fun at consumer fetishes and mainstream commercial obsessions, the series made viewers question how their own values and culture could be perceived by outsiders.

The brothers' prolific art output has slowed in recent years, but their puckishness still has punch. The evergreen impact of their art demonstrates the long-lasting potency of shock and satire to upset stiff cultural conventions. Their art gives radical, youth-fuelled, creative expression licence. Goya probably would have joined the Chapmans' cult following.

JUDY CHICAGO (1939)

—— FEMINIST GODMOTHER

Judy Chicago is the undeniable Godmother of all feminist art. Her aesthetic, too easily dismissed as 'hippie', cycles in and out of fashion, but her impact is unwavering. For any young woman looking to learn about *her*-story, Chicago's *The Dinner Party* (1979) is a vital starting point. Beyond creating art about women, Chicago's work celebrated and facilitated a sense of sisterhood and support among creative women.

Chicago was born Judith Sylvia Cohen. Her parents deviated from their lengthy rabbinical heritage, as Hasidic Jews, and became ardent Marxists. Unlike most families of their era, her mother worked as a medical secretary and her father, a postal employee, shared childcare duties. Both her parents passionately supported women's rights, in the early iteration of feminism, and encouraged their children's creative expression. Cohen was raised to recognise and resist systemic, subtle and overt oppression.

Cohen studied art and developed her activist voice at the University of Chicago and UCLA. After young widowhood and divorce, Cohen decided to change her name to define her, not a patriarchal lineage of male ancestors or husbands, and picked 'Chicago' because of her strong accent. Simultaneously, she began exploring herself – as an independent woman – in her art, pioneering the feminist mantra 'the personal is political'. Generous, warm-spirited, funny and angry – Chicago's work as an artist and teacher encourages women to love themselves and support each other.

Chicago is a powerful sex-positive feminist who sees sexuality as a principal life force and creates work encouraging women to own and enjoy their bodies. Her abstract paintings on Plexiglass from the late 1960s expressed the colours and sensations she felt when orgasming. By the late 70s, she had devoted five years to her masterpiece, *The Dinner Party* – a commanding installation of table settings, handicrafts, painted ceramics and history. Chicago designed this work to celebrate female figures in world history and imagine a summit where they all sat, as equals, sharing their accomplishments, ideas and glory. For the thirty-nine-piece 'party', she had place settings for women like Virginia Woolf, Susan B. Anthony, Sojourner Truth and Sacajawea. A 'heritage floor' in the centre of the triangular structure included 999 other names. It was a multi-cultural utopian gathering spanning centuries. Each woman at the table was represented by symbols of her achievements and a ceramic plate with a Georgia O'Keeffe-like image of her vulva. In an era when many women were just starting to explore their own private parts, using mirrors to see themselves and appreciate their bodies, Chicago's work boldly proclaimed pride in womanhood. Her message remains avant-garde in the 'pussy grabs back' era today.

JOSEPH CORNELL (1903-1972)

—— INTELLECTUAL MAGPIE

Joseph Cornell took abandoned and abused everyday objects to create treasured assemblage. His magpie masterpieces are iconic examples of how intellectual curiosity and appreciation for life's manifold potential is the greatest foundation for artistic genius. Cornell is a cult figure among visionary artists who understand that his sensibility validates small gestures of vast artistic significance.

Cornell was born in Upstate New York to a Dutch-born nursery school teacher and affluent textile merchant. Although his parents had aristocratic ancestry and his father was successful, when he died young the Cornell family fell on hard times. The little family moved to Queens, where Cornell spent his life. He established himself as a woollen-goods salesman and his working-class neighbourhood became his world. Throughout his life, he struggled with finance and was chronically reclusive, with high degrees of social anxiety. As the sole carer for a younger brother with cerebral palsy, Cornell's own life was limited. His emotional universe was filled with fan fixations for strong, assertive movie stars, notably Lauren Bacall. He befriended ballerinas in local companies, but no evidence exists indicating these infatuations were reciprocated. His intensely committed and creative relationship with the Japanese artist Yayoi Kusama (also a cult figure, see page 90) lasted his whole life, despite their twenty-six-year age difference, but remained platonic. Cornell used his art to express his connection to the world, lovingly and tenderly redeeming lost imagery and objects in his precious glass-fronted 'shadow box' sculptures, assemblage and experimental films.

Although Cornell's physical world was small, his imagination was limitless. He meticulously hunted through dime stores, antique shops and other repositories for ephemera. The illustrations and objects that captivated him often represented his long-standing interests in ornithology, ballet, astronomy, cinema and European history. Autodidactic, Cornell had an insatiable intellectual interest in the wider world and cosmos. Blending Surrealism and Constructivism, his art was full of wonder but lacked Dada's dark humour and edge. He was anything but cynical.

Before his death, Cornell's work received striking critical recognition, although his social isolation was consistent and seemed elective. He was a quiet man whose touchingly observant attention to the world enriched others' lives and continues to demonstrate the importance of valuing small beauties in a noisy world. In 2007, the *New York Times* accurately dubbed Cornell, 'a poet of light; an architect of memory-fractured rooms and a connoisseur of stars, celestial and otherwise'.

MOLLY CRABAPPLE (1983)

——— MILLENNIAL ACTIVIST

Instead of illustrating realities, Molly Crabapple uses her art to create change. An activist, journalist and artist whose vivid drawings reach far beyond the cloistered art world, Crabapple wields the ability to expose wide audiences to stories from the fantastical to the brutally real. She is an impassioned and powerful advocate for refugees, sex workers and the 99 percent. Her cult following includes newspaper editors and readers, the international literati and an endless legion of fans. Her work is adored and admired for mixing hard truths with joy and wonder.

Born Jennifer Caban, Crabapple was raised in a politically active and creative home by her Puerto Rican father and Jewish mother. One in a long line of artists, her mother sustained a steady life as an illustrator, demonstrating art as a viable career. After high school, Crabapple bypassed traditional art training and moved to Paris, where she started sketching in the historic Shakespeare and Company bookshop. She also became a sought-after artists' model and alt-pinup for Suicide Girls. Dissatisfied with staid figure drawing traditions, she co-founded the Dr. Sketchy Anti-Art School, a series of burlesque life-drawing sessions creating an international creative subculture. Her own sex-positive artwork connected contemporary cabaret with political complexities and autobiographical worlds of wonder. She drew burlesque dancers, acrobats, trapeze artists and their City clientele during residences at locations like The Box and Groucho Club in London. Depicting creative cities' cultural circuitry, Crabapple celebrated and deconstructed the connections between sex, art and power. Whether depicting the brutal realities of war or weaving phantasmagorical images of hedonistic fantasy, her artwork is empathetic and captivating. Within the traditions of Thomas Nast and Tom

> **❝** I WANT TO MAKE ART GOOD
> ENOUGH THAT PEOPLE WILL
> STILL WANT IT IF SOCIETY JUST
> EVAPORATES AND THEY FIND
> MY DRAWINGS SCATTERED
> IN THE WRECKAGE. **❞**

Otterness, it has a distinctly female sensuality and sensibility.

Crabapple's art became more overtly political during the Occupy Wall Street movement in Manhattan. Her satirical drawings were the signatures for the movement's main issues and outrage. As she says, 'political art should be out in the world. On the walls. On the streets.' *Rolling Stone* magazine dubbed her the movement's greatest artist for protest work connecting Occupy with histories of revolts and revolutions. In the years after Occupy, Crabapple has travelled to Guantanamo for *Vice* and *The Paris Review,* and rendered the horrors in Syria for *Vanity Fair* magazine, as well as published books of her war reporting and a memoir, *Drawing Blood.* She has collaborated with Jay-Z, Amnesty International, Human Rights Watch, the ACLU and the Equal Justice Initiative. *The New Yorker* magazine described her work as an 'amalgam of Hieronymus Bosch, Honoré Daumier, and Monty Python's Flying Circus'.

Evidence of Crabapple's vast and profound following is her ability to garner Crowdfunding resources for her projects. She thrives by giving visual voice to shared fantasies and concerns. Her transparency about financial realities for artists has opened candid conversations about inequality and stigma in art, making her a master at blending her extraordinary imagination with frank, progressive dialogue. She says, 'to make art is an act of both love and defiance'.

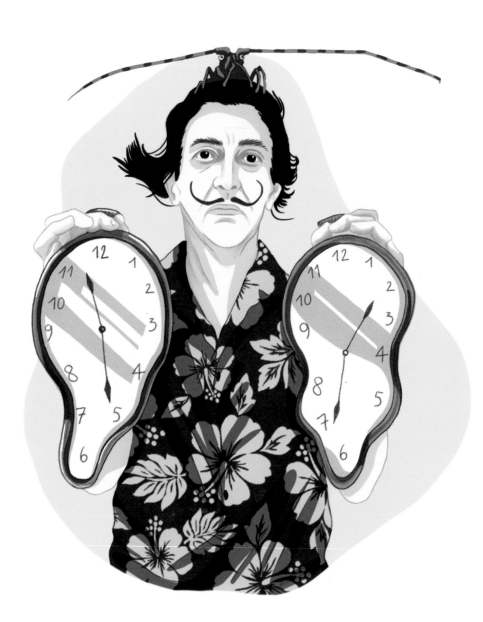

SALVADOR DALÍ (1904–1989)

—— SYMBOLIST MASTER

The prototypical art star, Salvador Dalí is among history's strangest and most popular artists. His phantasmagorical vision resonates with Freudian analysts, frat boys, movie stars and generations of transgressive artists. By using his masterful draftsmanship skills to represent a world beyond reality, he merged creativity with celebrity. He collaborated with fashion designers, courted publicity and shaped the public's understanding of human psychology.

Dalí's cultivated persona turned his life into a performance as grandiose as his art. Born into a bourgeois Spanish family, he was conceived when his brother died of gastroenteritis, and his obsessive belief that he was his brother's reincarnation became a central theme in his personal mythology. As an art student in Madrid, he fashioned himself after 19th-century British dandies and claimed Moorish ancestry. He grew his signature waxed moustache as a homage to Velázquez. When he moved to Paris, he befriended fellow avant-garde creators including Picasso, Buñuel, Miró and García Lorca.

While his peers pushed stylistic boundaries with Cubism and Abstraction, Dalí revived classical painting techniques to create shocking content across mediums. He is best known for painting but also produced related sculptures, films, drawings, fine jewellery and fashion – he collaborated with designer Elsa Schiaparelli on reality-defying *trompe l'oeil* garments. In all mediums, he sprinkled his work with symbolism referencing literature, mythology, his personal biography and Freudian psychology. He devised the term 'paranoiac-critical method' to describe why and how he combined certain disparate objects into one frame. *The Persistence of Memory* (1931), his most iconic painting, is a nightmarish vision of melted clocks in a mysterious landscape exuding fear and disorientation.

Many of Dalí's most important works celebrate his wife, Gala, a Russian muse for many pioneering surrealists. Ten years his senior, she became his creative collaborator, business manager and publicist. In his 1954 *Portrait of Gala with Rhinocerotic Attributes*, a photo-realist depiction of her disembodied smiling face hovers over floating rhino horns in an ocean-blue background. A more flattering, but almost weirder, 1944 depiction presents Gala naked underneath a giant fish bursting from a pomegranate and eating two tigers. When Gala died, in 1982, Dalí disintegrated. Although Gala's loss devastated him, in his prime he said, 'each morning when I awake, I experience again a supreme pleasure – that of being Salvador Dali'. Thanks to his singular vision, he shared the pleasure of his being with the world.

NIKI DE SAINT PHALLE (1930-2002)

—— FEARLESS FEMME

On par with the Louvre pyramid and Tour Eiffel, Niki de Saint Phalle's *La Fontaine Stravinsky* is one of Paris's greatest treasures. The sixteen, jubilant, fibre-glass figures moving in the fountain outside Centre Pompidou emanate and stimulate pure joy but they were born from Saint Phalle's turbulent personal history. By converting her suffering into singularly life-affirming sculptures, the autodidactic feminist artist became an eternally inspiring icon.

Saint Phalle came from a strict Catholic, wealthy, aristocratic family. Her father, Count André-Marie Fal de Saint Phalle, was a French banker and her mother was an American socialite. Despite fluctuating family finances, Saint Phalle was raised with significant material privilege in Connecticut and Manhattan but suffered secret horrors. Her mother physically and psychologically abused her children. In Saint Phalle's 1999 autobiography, *Traces*, she revealed that

her father began raping her when she was eleven. Similar childhood torture contributed to her two younger siblings' suicides in adulthood. Unlike them, she turned her traumas into fearless artworks.

As an adolescent, Saint Phalle modelled for *French Vogue, Elle* and *Harper's Bazaar*. A photo of her on the 1949 cover of *Life* magazine shows a serene-looking blond beauty in a white ball-gown, opera gloves and diamonds. She could have been Grace Kelly's little sister. Ten years later, a photo shows Saint Phalle looking very different. Still stunning with roughly chopped hair, she is seen holding a rifle to shoot paint onto canvas for her *Target Picture* series. Between the two images, she married a childhood friend and had a child before being institutionalised after attacking her husband's mistress with a knife and overdosing on sleeping pills. In a treatment facility, a therapist compelled Saint Phalle to

use painting as an expressive outlet. Fiercely polyamorous and free-spirited, Saint Phalle was also possessive and prone to rage. In 1956, Saint Phalle met Swiss sculptor Jean Tinguely and enlisted him to help her construct massive sculptures before leaving her husband for him. Their tumultuous relationship evolved into a life-long intimate friendship following a brief marriage and divorce. She played with her femme-fatale image in *Hon (She),* her 1965 sculpture, where viewers walk between the massive, multi-coloured, supine woman's spread legs.

Today, Saint Phalle might be diagnosed as having bipolar disorder triggered by her trauma history. Although her mental illnesses created wreckage, they also fuelled her profoundly rebellious art and life. Her art is enormous, insouciant, ultra-bright, vibrant, funny and exuberant. She supported black rights, women's liberation and the counter-culture with unique

fire and passion. At its core, her work is fiercely female. Everyone, from children onwards, feels uplifted by her art. It is her ability to turn pain into joy that makes her a vital, everlasting figure for all outsiders and survivors.

MARCEL DUCHAMP (1887-1968)

—— CULT ICONOCLAST

The cult of Marcel Duchamp is so profound and deep, ranging from art schools to punk rock and mainstream discourse, that he qualifies as the true Father of every irreverent artist challenging prevailing assumptions and systems. He employed snarky humour and a standard-issue urinal to create a game-changing aesthetic, transforming our understanding of what art means. Before Duchamp, artists were primarily identified by their craftsmanship and technical expression, but thanks to him artists can contribute pure philosophy and critique to culture. Fittingly, Duchamp was reported to emanate the serenity and presence of a guru: remaining calm while shaking up 20th-century culture.

Duchamp's signature artistic gesture was submitting a store-bought urinal, titled *Fountain*, to the 1917 French Société des Artistes Indépendants in New York. He signed it 'R. Mutt' (an homage to the urinal manufacturer's brand) in massive black letters across the porcelain base. Duchamp intended *Fountain* as a direct challenge to the society's claims of complete inclusivity and creative freedom. The society's governing body inadvertently played into his hands by rejecting his 'ready-made' piece and casting the question 'what is an artist?' into international debate.

Although this radical move shook the 20th-century art world, Duchamp did not emerge from nowhere. His work pushed Impressionists' challenges to art's boundaries to radical extremes. As for his own origins, he was raised in a highly creative home, with four of his siblings also becoming accomplished artists. His formal art training and scholastic achievements were limited but early in his life he established his satirical and technical skills with his Cubist painting *Nude Descending a Staircase* (1912). In this canvas, he attempted to depict a geometric figure in motion and earned his first creative controversy. The title alone evoked a family

rupture, with Duchamp's brothers outraged, and critics across Europe and North America greeted the work with condemnation and mockery. Even the former US president, Teddy Roosevelt, panned it in an op-ed. It took fifty years of neglect and derision to be recognized as ground-breaking.

For generations of his artistic disciples, one of Duchamp's greatest contributions to art was combining confrontational word-plays with surprising images. His titles were intended as challenges forcing viewers to question their assumptions. He clearly loved offending viewers' reverence for known icons, even defacing a cheap reproduction of the *Mona Lisa* with a well-waxed moustache.

Still in-tune with today's zeitgeist, gender and sexuality were repeated subjects of Duchamp's puckishness. In a collaboration with the iconic, Surrealist photographer Man Ray, Duchamp posed in drag as 'Rrose Sélavy' – a pseudonym designed to phonetically sound like *eros, c'est la vie* (or 'sexuality is life').

In a final act of artistic ingenuity, Duchamp made a graceful exit from the art world before his work grew stale or redundant. He became a competitive chess player and published chess critiques. Before his death, he made a quick return to creating art with a deeply disquieting tableau made of human hair, brass, velvet, twigs and other unconventional media. Only visible through peepholes in a wooden door, he constructed a mysteriously morbid scene of a nude woman, her head hidden, splayed in a landscape. Was she a murder victim or discarded mannequin? Like all his artworks, this final masterpiece left viewers with endless questions.

I DON'T BELIEVE IN ART. I BELIEVE IN ARTISTS.

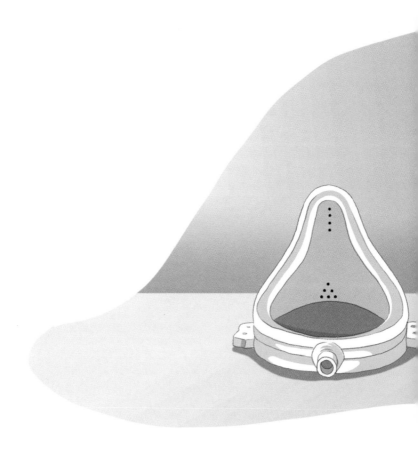

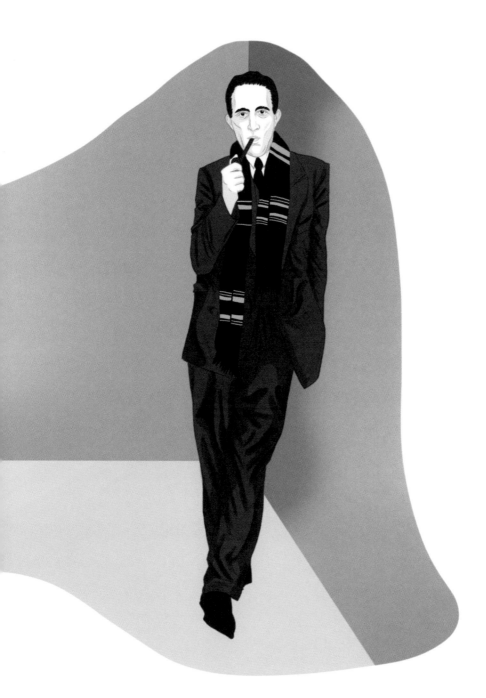

EL ANATSUI (1944)

—— CROSS-CULTURAL ALCHEMIST

El Anatsui's bottle-top quilts make visceral the global interconnections between consumer products, politics, environmental changes and cultural aspirations. Living and working from Nigeria, El Anatsui creates cross-cultural artworks representing enmeshment between Africa and the West. His art and practice is internationally revered, especially among artists and scholars of African descent. He was awarded art's highest honour, the Golden Lion for Lifetime Achievement at the 2015 Venice Biennale for his influence on contemporary art across continents.

El Anatsui described his work with bottle caps as representing 'the link between Africa, Europe, and America'. He employs young local men to mash bottle caps, aluminium packaging and other byproducts of Western imports into pliable metal 'cloths'. The patterns and textures recall traditional Ghanese kente cloths. These massive sheets of shining material move like fabric or mesh when installed in exhibition spaces. They pucker, fold and crease. Clusters of colours look like splashes of paint, replicating gestural abstraction with discarded junk. In *Bleeding Takari II* (2007), he created rivets of blood spilling from a silver sheet of 'cloth' onto the floor, turning the aluminium into an illusion of fabric and vital fluids. Under gallery lights, the metal is iridescent and alluring, appearing like precious metal but representing the 'fool's gold' promise of post-colonialist commerce.

For El Anatsui, who lived and studied in Ghana before teaching for decades in Nigeria, these works speak directly to colonial histories of destruction and harm – specifically traders' histories of using alcohol as currency when visiting Africa, thereby introducing and promoting oppressive epidemics of alcoholism. Before his bottle caps, El Anatsui used ceramics, paint and panels of wood scarred by chainsaws and oxyacetylene flame to symbolise colonialism's destruction to Africa's landscape and culture. In 2003, he used discarded printing press plates, those used for obituaries, as his medium. He employed Uli motifs, Nsibidi signs, Bamum scripts, Adinkra symbols and Vai scripts in abstract images fusing African and Western creative expression.

El Anatsui's ethos focuses on working within his local environment in response to immediate, topical issues. 'Art grows out of each particular situation', and according to him, 'artists are better off working with what their environment throws up'. Using this alchemic approach, he's brought the physical material of cultural exploitation to life, transcending its ugly origins to create precious, thought-provoking, dynamic works that bridge cultural divides.

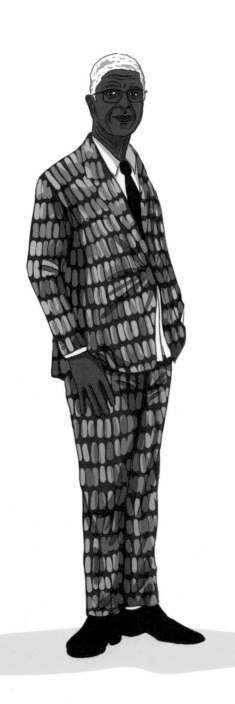

JAMES ENSOR (1860–1949)

—— RADICAL HERETIC

James Ensor is a perennial cult figure for his morbid but merry politically polemic paintings, drawings and etchings. He evenly balances horror and humour in artworks that scandalised and enraged Belgium's straight-laced cultural elite. His punkish energy was so radical, in his era, that he was justified in creating an 1887 self-portrait depicting himself urinating against a wall with graffiti reading 'Ensor is Insane'. But he eventually infiltrated art's canon. By 1929, he was named a baron by Belgium's King Albert. He was awarded the *Légion d'honneur* in 1933 while remaining an ongoing figure of artistic resistance.

When Ensor started exhibiting his work, at age twenty-one, his palette was sombre, and he preferred social realist subject matter. As Belgian society became increasingly ignited, Ensor started employing bright colours, riotous energy and magic realism to criticise mass culture's hypocrisies, vulgarities and cruelty. His signature subject was a crowd of hysterical faces, in deceptively cheerful colours, clamouring around a comically inept leader. He loved chaos and welcomed profanity, even showing King Leopold II and his officials squatting, dripping faeces on their followers in the 1889 etching, *Belgium in the XIXth Century* or *King Dindon*.

Ensor's faux-naïve style offended his era's art critics, who were repulsed by his use of palette knives, spatulas and both ends of his brush to paint. As a powerful precursor to Expressionism, Dada and Surrealism, Ensor's art combined political satire with intense, chaotic imagery. His infamous *Christ's Entry into Brussels in 1889* presented a sea of unsavoury characters – aka: the masses – in Mardi Gras masks and formal attire, ignoring the lonely saviour attempting to liberate the oppressed in the background. With his halo and raised arm, Christ is recognisable from art's history but the self-obsessed crowd clusters around a politician, dressed like a bishop. According to contemporary criticism, Ensor associated himself with the Christ figure, a reoccurring motif in his art.

Ensor's magic lies in overlaying patches of colour across the canvas, so figures seem to spill out towards the viewer. He created the illusion that viewers were in danger of being overwhelmed by the hysterical masses pushing outwards. As Ensor felt rejected by Belgium's strict, conservative high-society and art world, the frenzy and fury in his work increased. His art grew sharper, funnier, brighter and bolder as society pushed him away, until he changed the society – going from outcast to avant-garde hero.

H. R. GIGER (1940–2014)

—— DEMONIC DREAM-MASTER

Fetishists, sci-fi fanatics, tattoo artists, goths, cyber-punks, film directors, scientists and other counter-culture creatives idolise H. R. Giger. His influence is profound because his erotically charged cyborg vision shaped our collective imaginations and foresaw our current interlocked relationship with technology. The fantastic realist world of Giger's creatures seamlessly merged humans with machines. Giger's paintings, sculptures and set designs inspire awe and terror because he combined technical mastery for replicating reality with his obsessions for sex, death and the occult. Although we remain physically distinct from our mobile phones, for the moment, Giger's bewitching imagery appears unsettlingly prophetic.

The bucolic city of Chur, where Hans Ruedi Giger was born, is an unlikely inspiration for his dystopian imagination. By all accounts, his childhood was loving and modest. His father was a pharmacist who wanted his son to join his steady, secure profession. Instead, Giger was fascinated by morbidity and images of Jean Cocteau's sensual surrealism seen in American soldiers' magazines. When his father urged him into university, Giger studied Industrial Design and Architecture. During his career, he employed technical skills and references acquired in his studies to create his vivid, multi-dimensional artworks.

Part of Giger's genius was creating a singular but consistent aesthetic. He had a signature spectral palette – ranging from steel grey to rust and impenetrable black – and used airbrushing instead of oil or acrylic paint. His work is hallucinogenic, but he claimed to never use drugs. His visions came only from dreams.

In 1979, Giger's aesthetic was introduced to mainstream culture. His book, *Necronomicon*, inspired director Ridley Scott's Oscar-winning film *Alien* and the two collaborated together on the film's groundbreaking special effects. The scene of Giger's multi-mouthed creature millimetres away from the female protagonist's face haunted a generation's dreams and joined the utmost iconic cinema moments in the 20th century. The creatures Giger crafted remained haunting for their relatability and nuance, not only their fantastical appearance. Graceful and complex, his demonic designs evoked more than fear in audiences. The alien in Scott's movie was a character, not just a monster.

Although Giger's work, personal style and internal world were deeply sinister, he was universally known for his warm, gregarious, generous, highly empathetic spirit. Early in his career, Giger became a grandfatherly figure for punk rockers, art students and other radical misfits. Scott eulogised Giger by saying 'he was a real artist, and a great eccentric, a true original, but above all, he was a really nice man'.

GILBERT & GEORGE (1943 (GILBERT) 1942 (GEORGE))

—— ECCENTRIC RENEGADES

This quintessentially eccentric British duo have been collaborating together since 1967, when they met studying sculpture at Central Saint Martins. They fell in love at first sight and, ironically, George was the only person on their course to understand Gilbert's English – Gilbert Prousch is technically Italian, and was raised speaking Ladin. A further irony is that their collaborative living sculptures, massive backlit photo-collages and public installations defined radical British art for generations and their perfectly choreographed public persona is an ongoing satire of British drudges. Despite looking like archetypical bureaucrats, Gilbert & George are known as quintessential punks who aspire to create consistently unsettling 'Art for All'.

Gilbert & George are cult figures for the brilliantly sharp juxtaposition between their poised self-presentation and fearlessly critical, tough, demanding handling of taboos from racism to the monarchy to patriotism and scatology. Their art features images of their own faeces, pubic lice, sperm and urine. They create imagery some see as glorifying skinhead culture. They celebrated London's pre-gentrified East End for its roughness and pushed art out of its frosty gallery confines. But, they are also cult figures for their immutable, aspirational love. They dress in matching immaculate tweed suits and are always, beautifully, together. They met when homophobia was the norm but married in 2008 and remain together, living in an 18th-century house in Spitalfields. The acerbic sarcasm, cynicism and brutality seen in their art is poetically contrasted by the sweetness they embody.

The couple began their artistic careers as living sculptures before they started creating collage series like their *Dirty Word* pictures and *Human Bondage* in the 70s. The visual language and subject matter seen

> **" WE WANT OUR ART TO BRING OUT THE BIGOT FROM INSIDE THE LIBERAL AND CONVERSELY BRING OUT THE LIBERAL FROM INSIDE THE BIGOT. "**

in these series defined their aesthetic and artistic identities for decades. These series of massive photographs include profane graffiti, or the words written in steamy windows, and swastikas. They prefer red, black and beige in their art and a signature grid, dividing the images like stained-glass windows. Their work is simultaneously chaotic and extremely orderly. In many images, they insert their own distinctly everyday faces – where they hover like spectres of English respectability over the human filth they're gathering in their captivating oeuvre. The tensions they express and explore are universally relatable as Gilbert & George's 'Art for All' and demonstrate that everything can be art.

GUERRILLA GIRLS (FORMATION: 1985)

—— POWER'S WORST NIGHTMARE

The Guerrilla Girls are cult icons and cultural heroes because (not despite) their identities are unknown. Using brutal statistics, gorilla masks and sharp humour, the anonymous activists hold a mirror to the art-world's systemic sexism, racism and hypocrisy. For decades, they've produced books, talks, protests, murals, billboards, museum shows and endless pamphlets relentlessly fighting for social justice.

To inaugurate the opening of its new building in 1984, the Museum of Modern Art organised 'an International Survey of Recent Painting and Sculpture'. The roster was celebrated as the era's most important creative visionaries and the curator mocked excluded artists. Of the 165 artists shown, only thirteen were women. There were no women-of-colour. The Guerrilla Girls formed to protest this injustice.

On wheat-paste posters plastered throughout New York City, the Guerrilla Girls first exposed the MOMA's toxic biases before expanding to countless other examples of oppression and suppression. Starting with Manhattan's rarefied art world, the Guerrilla Girls extended their reach to rip masks off the worlds of literature, film and mass media. Throughout their history, the group has used satire and raw data to fight conservative politicians, tyrannical corporations and America's unending war machine.

The Guerrilla Girls' most famous culture-breaking find was that 5 percent of artworks in the Metropolitan Museum of Art's public collections in 1985 were created by women, while 85 percent of nude subjects were female. The concept of the 'male gaze', which was coined by film-critic Laura Mulvey and central to second-wave feminist theory, explains how men objectify women while denying their agency or desires. Nothing demonstrated the supremacy and reality of this theory like the Guerrilla Girls' statistics. Representation was a small, but striking, part of their agenda. The Guerrilla Girls have also fought for fair labour practices and drawn media attention to injustices in pay and treatment of the art world's blue-collar support staff.

Because the group remains anonymous behind their massive monkey masks, the members easily infiltrate art institutions to investigate demographics. No one knows the artists, curators, critics and staff in the movement, but they honour women pushed to the periphery of art history. When in costume, they borrow and share names from iconic women artists like Frida Kahlo (see page 74) and Käthe Kollwitz. Because the Guerrilla Girls' identity has never been fixed to any individuals, they're perfect spirit animals for today's social justice battles. Nothing could be more contemporary than a gorilla mask paired with a pussy hat.

NAN GOLDIN (1953)

—— FROM OUTLAW TO WARRIOR

Artist and activist, Nan Goldin is one of photography's most poignant and powerful visual voices. She revealed the glamour, pathos and importance of her friends and lovers in New York's underworld during the 1980s and 90s. The feral intimacy and immediacy of her autobiographical artwork has shaped subsequent generations of celebrated avant-garde photographers like Corinne Day, Ryan McGinley and Cass Bird. In her activism, she battles art's most cloistered establishment powers to fight for justice for people dying on society's fringes, using her own suffering as a muse and motivator. Beyond being a cult icon, Goldin has become a hero.

When Goldin was eleven, her incandescently beautiful older sister committed suicide. In the conservative Jewish community where Goldin and her sister were raised, suicide was a taboo topic and Goldin recognised sexual repression as a contributing factor in her sister's death. When she moved to Manhattan in the early 1980s, she chose the LGBTQ communities of sex workers and other outlaws as her tribe. She documented their lives – fighting, having sex, using hard drugs – and set a slide-show of her images, titled *The Ballad of Sexual Dependency*, to music by The Velvet Underground and Nina Simone. The results found their way to the Whitney Biennial and instantly became iconic representations of New York's demi-monde. AIDS became a central subject for Goldin, as many of her friends lived and then died from the disease.

By showing the pain of homophobia, class stigma, and stigma against sex workers and people suffering from addiction disorders in her family-like community, her images, like David Wojnarowicz's activist art, exposed the prejudice and neglect that kept the US government from providing AIDS sufferers with treatment options.

Goldin now devotes her powers to protesting another epidemic. Hard drugs, especially heroin, were a consistent part of Goldin's own story but she got clean for decades before being prescribed OxyContin, an addictive prescription opioid. Her resulting addiction was the most battering experience of her life. She documented it before getting sober and rallying her enormous influence to publicly shame the Sackler family. The Sacklers fund art and educational spaces in Oxford University, the Metropolitan Museum of Art and similar institutions but gained their wealth through the pharmaceutical company responsible for OxyContin. Using her sobriety as her inspiration, Goldin stages protests in Sackler-owned spaces, demanding the family fund rehab facilities, and she's successfully compelled the world's leading art institutions to reject grants and donations from Sackler.

From documenting social realities, Goldin has turned towards changing them, demonstrating how renegades can become revolutionaries.

JENNY HOLZER (1950)

—— SUBVERSIVE STORYTELLER

Jenny Holzer is a storyteller. Her textual projections, installations and sculptures combine art, poetry and politics to unique effect. Before Twitter trimmed everyone's communication, she was using the fewest possible characters to make the strongest possible statements. The phrases she broadcast in white lettering, across black backgrounds, were eye-opening and philosophical – exposing hypocrisies but also life's manifold potential for hidden beauty and meaning. 'In a dream you saw a way to survive and you were full of joy', is an example of Holzer's artistic gifts to people fortunate enough to encounter her public artworks. 'You are a victim of the rules you live by', is another of her paradigm-shaking pieces out in the public sphere.

Holzer ironically started out as an abstract painter. For an artist whose work went beyond depicting visual references to actually using language, abstraction seems like starting on the opposite end of a dialectic spectrum. After studies at Duke University, the University of Chicago and Ohio University, Holzer started creating word pieces while engaging in the Whitney Independent Study Program in New York. *Truisms* was the aptly named first series of her text works, in 1977–79. Like Basquiat's art as SAMO©, Holzer used graffiti-style art to disrupt conventional thought by putting

signs up around Manhattan that condensed complex academic texts into engaging taglines. She started by scattering her word-works in telephone booths and smaller spaces, before occupying spaces and places usually reserved for consumer advertising.

Holzer's art developed new life when she started using technology to transmit her aphorisms. She started with wheat-paste posters, stickers and T-shirts, but grew to use neon, light-projections and LED tickers (usually associated with stock-market news reports). Her *Red Yellow Looming* used thirteen LED signs to broadcast codes, stats and dispatches from the State Department about the war in Iraq, using a visual language associated with stock tips. This combination of information and medium is a uniquely effective artwork highlighting the cynical and callous interconnection between war and capitalism.

For being a woman artist whose passionately activist, progressive, philosophical works defy gender stereotypes and barriers, Holzer has become a true feminist icon. Her cult followers are feminist artists and activists, alongside people of all genders fighting to subvert and disrupt late-stage-capitalist thought. Holzer's messages and signs borrow tactics from Orwell, seemingly giving viewers direct orders, while forcing us to all think for ourselves.

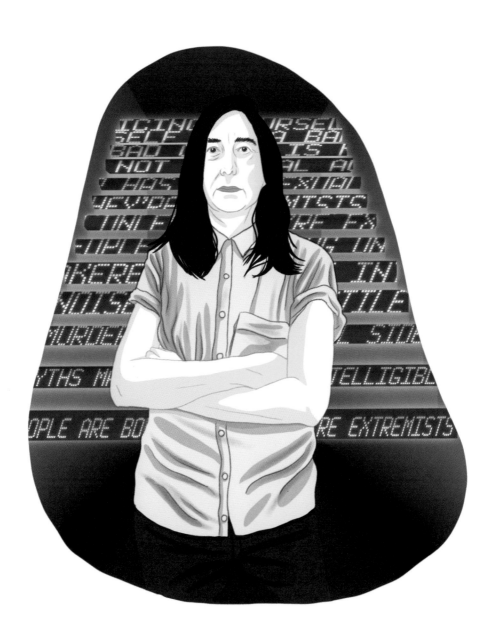

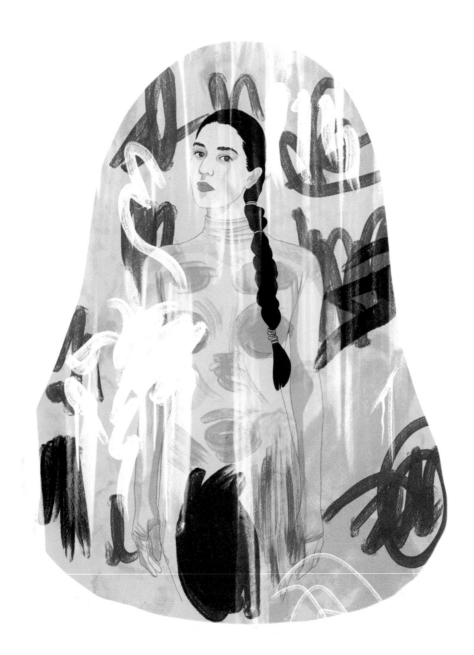

DONNA HUANCA (1980)

—— BODY WHISPERER

Donna Huanca's paintings, living sculptures and performances demonstrate the power of softness. By employing a pastel palette, evocative smells and skin-like textures to create strong statements about gender-fluid empowerment, she's become an artistic voice for this generation of proud feminists. Her art is seductive but critical, with an equal balance between surface and depth. Huanca is known as a tough, compelling woman and she collaborates with kindred spirits, of all genders, from Berlin's dance and music scenes, who act as her answer to Yves Klein's 'human paintbrushes' (see page 84). When she has exhibitions in Berlin and London, they are welcomed by crowds of fans who admire her cool, intelligent remixing of art-historical references and contemporary cultural concerns.

Like many first-generation Americans, Huanca developed an identity straddling two, often clashing, cultures. Huanca's parents moved from Bolivia to Chicago in the 1980s. She wasn't allowed to speak English at home because her parents believed their time in America was temporary. After studying art in Maine, Texas and Frankfurt, Huanca continues her nomadic existence by living between Berlin and Brooklyn. In her work, she draws equally upon American beauty culture, Western art history and her childhood experiences attending the Virgin of Urkupiña festival in Bolivia. The festival,

fusing Catholic and Andean traditions, incorporates dance, costumes and colours. Huanca's performances and related artworks are not narrative, like the fantastical Urkupiña festival, but contain comparable otherworldly drama and opulence.

Huanca's signature is her consistent use of mint green, azure, turquoise and pale peach in the pigment coating her live models, which they use to imprint her massive photographic images of skin. The cis or trans men and women, of all shapes, in her work move methodically slowly through exhibition spaces. They are languid but not passive. Her sculptures are comprised of body-stockings, latex, bolts of leather and minimalist sex toys. Commercial cosmetics are a reoccurring medium for her work but she uses the powders like raw pigment. Whereas female models are routinely objectified in traditional art history, Huanca's collaboration with the nude performers in her work is central to her art-making process. She asks her models to journal privately about their experiences appearing naked for art audiences in famously sex-positive cities. Huanca herself has the bearing, style and charisma of a rock star. She is a cult figure because her example and work demonstrate the majesty of people owning and defining beauty, across cultures and identities, for themselves.

DOROTHY IANNONE (1933)

—— EROTIC LIBERATOR

I Lift My Lamp Besides the Golden Door, Dorothy Iannone's majestic mural on New York's High Line, depicts three Amazonian iterations of the Statue of Liberty but they could be self-portraits. Iannone has been a tireless champion of freedom of expression, especially sexual expression, since she started creating art in the 1950s. Her intimate, open, complex and deeply arousing exploration into eroticism is now being welcomed into the feminist and contemporary art canon. Previously pushed to the periphery, in her eighties she has transcended a niche cult following to become a defining artist of our era. Her joyfully lusty paintings, artist books and drawings represent romantic obsession, existential exploration and the irrepressible power of women's stories.

Boston-born, Italian-American, Iannone met the artist Dieter Roth in 1967, when she was married to another painter. She left her husband and became the celebrated Swiss conceptual artist's muse. He called her his 'lioness' and she depicted him in her art as a God. When the couple split, Iannone continued to create work about their relationship, her fantasies and her feelings throughout her career. In 1969, for example, she created a handmade artist's book, titled *A Cookbook*, combining recipes she made him with graphically illustrated reflections on their relationship and erotic entanglement. Roth became her muse. Her art expressing her fixation with him is tortured but seductive. She portrays herself as a siren, sufferer and ultimately author of their story in the text and imagery she employs to expose a relatable experience of love and heartbreak. Throughout her work, her vision of empowered and greedy female sexuality overrides the specific disappointments in her saga.

As a leading artist representing women's unedited sexual desires, censorship has

defined Iannone's creative life. In 1961, Iannone won a massive victory of American sexual expression when she sued the US Customs for confiscating her copy of Henry Miller's *Tropic of Cancer*, a book banned for its graphic sexuality. Despite her victory for dirty books, she was a regular target for US censors and routinely dismissed as an 'outsider' artist by the international art establishment. She had a fierce cult following, including George Brecht and Robert Filliou, once she started exhibiting but other feminist artists also belittled her work as solipsistic. It was not until the early 2000s, when she had a retrospective at New York's New Museum titled '*Lioness*', that her autodidact work became widely recognised as instrumental in recent art history. Now, living in Berlin and represented by the taste-making Peres Projects gallery, Iannone is being lionised by the art world.

FRIDA KAHLO (1907–1954)

—— PAIN ALCHEMIST

The word 'cult' usually refers to influential subculture status but Frida Kahlo is almost deified in mainstream culture. Token-like objects bearing her image, as an icon of suffering, pride, strength and empowerment, are nearly ubiquitous. A Barbie was made of Frida Kahlo in 2018. This regal doll, with her unnervingly intense gaze, joins countless mugs, T-shirts, student posters and similar everyday objects showcasing her striking face and powerful self-portraits. Madonna famously collects her paintings and Beyoncé even dressed as Kahlo for Halloween.

Kahlo's artwork is not an obvious sell for a coffee mug. Her self-portraits show her dressed as a man, her organs spilling from her split stomach, or a sinister monkey wrapping a red ribbon around her throat. Kahlo strengthened the severity of her facial hair (her signature unibrow and hint of a moustache) in her self-portraits.

Her astonishing non-binary beauty, combining these masculine attributes with delicately feminine features and traditional Mexican floral headdresses, makes her an unparalleled contemporary figure despite her death, after a lifetime of physical anguish, from bronchopneumonia in 1954.

In many ways, Kahlo's emotional and physical suffering was her creature salvation. She was in pain throughout her life. She had polio at age six and a nearly fatal bus accident, when she was eighteen, left her with chronic pain. Kahlo met the famed artist Diego Rivera when she was a schoolgirl. Portly and bearish, Rivera was not a traditionally handsome man, but he celebrated intelligent and strong women. The feelings were mutual and he was equally renowned for his womanising as his politically and philosophically confrontational murals and paintings. When Kahlo was in her teens, he saw authentic

talent and artistic energy in her paintings. His mentorship evolved into a tumultuous marriage that fuelled both of their intellectual and creative spirits.

Kahlo's creative genius was blurring all boundaries between her interior self, her life and her canvases. In all areas of her life, she dressed to celebrate her Mestizo heritage as an anti-colonialist statement and depicted herself as a semi-mythic Mexican figure in her art. She perceived herself as a symbol and icon, staking claim over her appearance and its power instead of becoming a muse for the male artists and activists in her life.

Just as Kahlo changed ideas about what is beautiful, she transformed our understanding of what is political. Rivera created overtly activist artwork commenting on social justice and income inequality. In their era, Kahlo's work was interpreted as comparably solipsistic. She focused on herself, her own image, her life story, her dreams and her radical vision. Although her images were transgressive, the power of their politics was only understood decades later when the feminist movement championed the rallying cry 'the personal is political'. Kahlo illuminated the universal issues of suffering and survival with her feminist, humanist, intimate and deeply revolutionary art.

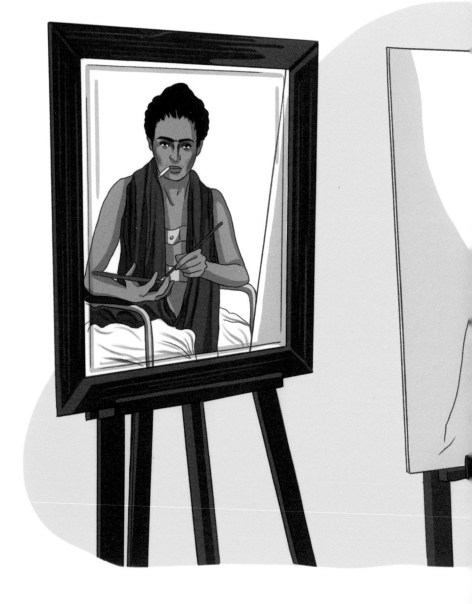

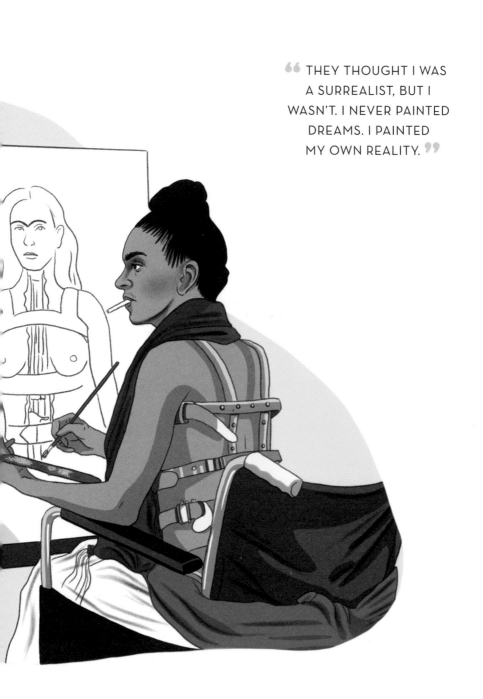

THEY THOUGHT I WAS A SURREALIST, BUT I WASN'T. I NEVER PAINTED DREAMS. I PAINTED MY OWN REALITY.

ALLAN KAPROW (1927–2006)

—— ENVIRONMENTAL ANTI-ARTIST

Allan Kaprow is adored and revered for following his youthful edict to create art from 'paint, chairs, food, electric and neon lights, smoke, water, old socks, a dog, movies'. Kaprow's creation of performance works that he termed 'Happenings' broke down barriers between art and life. He preferred perishable, everyday, material over craft and his happenings were, in his words, 'events that, simply, happened'. For a man who described himself as an 'un-artist' and whose goal was creating a tiny footprint, he's left a massive legacy changing the course of 20th-century art.

Kaprow was concerned about the environment, waste and our increasing inability to be mindful long before mobile phones, recycling or fast-fashion overproduction. Although his art appeared improvisational, it was rooted in art history and his personal biography. Born in New Jersey, he spent his childhood in Tucson, Arizona before studying art history at Columbia University. The vastness and majesty of Arizona's desert nature inspired Kaprow, an ardent, life-long environmentalist and, after a brief stint as an abstract painter, he rejected conventional media for pioneering, nature-based performances.

Kaprow's 1993 book *Essays on the Blurring of Art and Life* is the definitive treaty for artists seeking to find how art fits into real life. For Kaprow, that fit often involved mountains of used tyres or freshly squeezed orange juice. Audience members were dragged into surreal events when they attended Kaprow's shows, dissolving the membrane between an artistic fiction and reality. Occasionally, Kaprow added viewers' unease and concern as ingredients into his 'Happenings'. For a 'Spring Happening' (1969), viewers were packed into narrow tunnels and exposed to flashing lights and sirens. A performer ended the event by pushing out audience members by approaching them with a rolling lawnmower. In another 'Happening', this threat and discomfort was replaced by joy and serenity when a young woman squeezed fresh orange juice in a room littered with tar paper and oranges, which rotted and hardened over time.

Like the audiences for a 'Spring Happening', Kaprow pushed art out of its narrow confines into abandoned buildings, random public spaces, car parks and high school gyms. Sometimes his fixation with the everyday brought him into micro-artworks, like his long-term project documenting his dental hygiene routine in the 1980s. Picking up from Duchamp's world-changing *Fountain*, Kaprow is a cult artist for teaching us that art is anywhere and everywhere.

MIKE KELLEY (1954-2012)

—— PUNK PHILOSOPHER

Mike Kelley turned orphaned toys, cast-off blankets and other banalities into weapons to confront American working-class culture with its hypocrisies, assumptions and suppressed pain. Alongside his friend and collaborator Paul McCarthy, Kelley made Los Angeles in the late 1980s and early 90s into America's nexus for raw, dark, feral, punkish creativity. Their pungent poetic art exposed latent traumas for generations of artists, musicians and creative radicals. Kelley's acerbic, cynical humour voiced his generation's feelings of abandonment, disillusionment and caustic intelligence. Kelley remains an iconic figure with a cult-like following.

Kelley grew up in a Detroit suburb. His father was a maintenance man and his mother worked as a cook in the Ford Motor cafeteria. Art was one outlet for Kelley, who also performed in the brutal punk noise band Destroy All Monsters and wrote art criticism. He originally aspired to become a

novelist but turned towards art as a more direct means of expression. During his MFA, he studied under Laurie Anderson and John Baldessari, at the California Institute of the Arts and started using toys and handcrafts as media for semi-satirical abstract artworks. His conceptual multi-media collages were part Pop Art/part abstraction. Kelley became a forerunning figure in the Los Angeles art scene, which combined serious conceptualism with a fixation on life's darker undercurrents, a direct contrast with the city's bubbly, sunny, glitzy mainstream culture.

More Love Hours Than Can Ever Be Repaid (1987), his most celebrated work, stitched handmade blankets and stuffed toys into a tapestry of need, hope, anxiety and isolation. The worn handcrafts were scavenged by Kelley from thrift store bins where they ended up, despite being lovingly created for intimate friends or family. He assembled them as a challenge to happy

family fantasies, exposing hidden histories of loneliness, rejection and loss. In 1999, he screened a short film of Superman reading from Sylvia Plath's *The Bell Jar*. He collaborated often with musicians, including Sonic Youth, on albums and performances blending punk with art. Kelley's closest temperamental twin was Kurt Cobain, they both embodied and shaped the cantankerous Gen X brand of genius – sarcastic and hurt but ultimately ethical and outraged.

Kelley, who acknowledged his dysfunctional childhood and ambivalence about art-stardom, rejected biographical and pseudo-psychological interpretations of his work and mocked the idea that repressed abuse explained his, or others', artwork. In 1995, he started his extended '*Extracurricular Activity Projective Reconstruction*' project, creating a faux-autobiography that confused fact and fiction – exploring how identity and social norms are shaped.

When Kelley committed suicide in 2012, his fans contributed handmade stuffed toys, blankets, candles and other intimate items to recreate *More Love Hours...* Their homage to him, which was ultimately donated to the Mike Kelley Foundation for the Arts (an extension of his philanthropic work), demonstrated the sincere and reciprocal impact he, and his love, had on others.

“ I DECIDED AT THAT TIME, IT WAS
THE MOST DESPICABLE THING YOU
COULD BE IN AMERICAN CULTURE.
IT WAS LIKE PLANNED FAILURE. ”

YVES KLEIN (1928-1962)

—— CONCEPTUAL MAESTRO

Yves Klein harnessed fire, sea creatures, sound and women's naked bodies for his life-affirming, spiritual, conceptual paintings, sculptures and performances. Klein's work, and life, were defined by a strong juxtaposition between corporeal and cerebral elements. He brought together, but refused to blend, earthly and spiritual influences, showcasing the strength and beauty in both. As people become more comfortable defining the notion of a 'higher power' for ourselves, Klein's work becomes increasingly relevant and meaningful.

Klein was born into art. Both his parents were prominent painters but his work was increasingly conceptual. His *Monotone Symphony* (1949), for example, was a single note played continuously for twenty minutes followed by a twenty-minute silence. Counter-balancing this heady art were his accomplishments in Judo. When he was twenty-five, he was recognised in Japan as a master and trained until his early death from heart disease.

Klein's greatest contribution to culture might be International Klein Blue (IKB), a lapis lazuli he mixed and trademarked in 1960. The intensely captivating colour was created with an art supplier who suspended the ultramarine in a synthetic resin binder, creating an unprecedented deep matte pigment. Klein slathered this extraordinary paint onto massive canvases, creating a uniquely serene and exalting experience for viewers. Klein would apply this paint with pudgy sea-sponges that he often fixed to the canvases, making an earthly (or watery) juxtaposition to the almost divine, hypnotising IKB.

In the early 1960s, Klein went further to merge worldly temporality with his IKB by collaborating with dancers and models as 'human paintbrushes'. For his *Anthropometry* series, naked women slathered themselves

in his signature colour and made imprints
of their bodies on canvas. Klein, dressed
in a bow-tie and suit, orchestrated their
movements. This use of women as materials
has been heavily criticised and directly
satirised by feminist artists like Karen Finley,
Janine Antoni, and Donna Huanca (see
page 69). These women, using themselves
or fellow feminist collaborators, seek
to reclaim women's nude bodies from a
patriarchal directive, but Elena Palumbo-
Mosca, one of Klein's original models, has
publicly defended him and her role in his
art. According to her, Klein encouraged the
women to express themselves and co-create
the artworks, as creative partners.

Beyond gender, Klein's artworks are cult
classics celebrating everyone's potential to
connect with the Universe, as represented
by his creation of a singular divine colour.

BARBARA KRUGER (1945)

—— SPEAKING TRUTH TO POWER

Beyond being 'woke', Barbara Kruger's art has awakened generations of women to social injustices, hypocrisies and toxicity. She uses the visual vernacular of everyday advertising to push priceless enlightenment. Her slogan-style artworks are constantly powerful presences in protest marches and spaces devoted to women's ongoing fight for liberation. Her 1989 *Untitled (Your body is a battleground)*, created for a pro-choice protest, showing a well-groomed white woman with the words in the title superimposed over her expressionless visage, remains an omnipresent image at women's marches everywhere. Alongside Cindy Sherman, Martha Rosler, Jenny Holzer (see page 66) and Sherrie Levine, Kruger deconstructed sexism and aggression against women using appropriated imagery.

Born into a lower-middle-class home in New Jersey, Kruger attended the prestigious Parson's School of Design to earn a living in publishing. During the 1960s, her work as a graphic designer and freelance editor gained her fluency in the language of advertising. In contrast to her editorial work, Kruger's early artwork, showcased in the 1973 Whitney Biennial, made use of beads, feathers and ribbons and was unrecognisable from her signature style. She then experimented with minimalist abstraction before finding her voice in the late 70s. It wasn't until she combined her political consciousness with the skills and aesthetic acquired at her day job that she became a revolutionary figure.

Beyond her art, Kruger makes an indelible impact on contemporary culture through her teaching and activism. She has donated art made for domestic violence groups, pro-choice organisations and the US public school system. Her art is equally at home in the streets and museums. She has launched billboards and adorned public buses with her electrifying slogans, as well as organised a group called 'Artists Meeting for Cultural Change' to challenge art's cloistered status.

In many ways, the unending relevance, cult status and power of Kruger's work is a tragic reminder that the problems she protests continue to suppress and oppress women. Kruger is a cult figure for women and social justice activists because she is a symbol of hope and resilience in resistance. Until the world becomes a safer, fairer, better place for women, Kruger's art will be seen outside museums where it will always be a smart, sharp weapon in the hands of her fearless fans.

YAYOI KUSAMA (1929)

—— DOTTY POLYMATH

Yayoi Kusama, known as the 'Polka-Dot Princess', is adored by fashion designers, students, feminists and curators. Her cult spans continents and, since the 1960s, the New York-based artist has been among Japan's leading creative voices. The polka dots comprising Kusama's multi-media works, ranging from all-encompassing installations to painted porcelain pumpkins, painted horses, phallic sculptures and collaborations with Marc Jacobs for Louis Vuitton, are instantly identifiable and widely appreciated but often misunderstood. Her dots and mirrors, which she terms 'infinity nets', and predilection for strong, primary colours spark joy, and endless Instagram photos, but her signature aesthetic was inspired by physical and psychic pain. As a child, she started experiencing hallucinations involving fields of spots and animated patterns in her everyday surroundings. When seeing the dots, the experience made

her feel 'as if I had begun to self-obliterate, to revolve in the infinity of endless time and the absoluteness of space, and be reduced to nothingness'. By harnessing these distressing visuals, she formed her artistic vision and transcended the terror of mental illness through creativity and artistic determination.

Like Louise Bourgeois (see page 25), Kusama's imagination and identity were permanently shaped by early exposure to her father's intimidating sexuality. Her affluent family owned a horticulture business in Japan but was fraught with dysfunction. Her mother physically abused her and enlisted her to voyeuristically report on her father's infidelities. Witnessing her father's sexual expression created a conflicting fixation and repulsion within her. Her rejection of sex and obsession with it defined her intrapersonal identity and erotically tense art. Her fascination with her father, and fear of her

mother, remained themes throughout her art. Her self-portrait laying nude, covered in dots, on a spiked sofa and pile of pasta, is an iconic image of 1960s sexual decadence and exploration, although at the time, Kusama identified as above sex (although she offered to have sex with Richard Nixon if he stopped the Vietnam War).

Using sexual allure, humour (Kusama loves including pumpkins in her work, because she finds them amusing) and optical illusions, Kusama creates vast statements about life's potential and the world's greater meaning. Whatever the medium that Kusama covered with her dots, she identifies her work's core as 'a preoccupation with infinity and the search for peace and love'. In her generations of fans, she has found the latter.

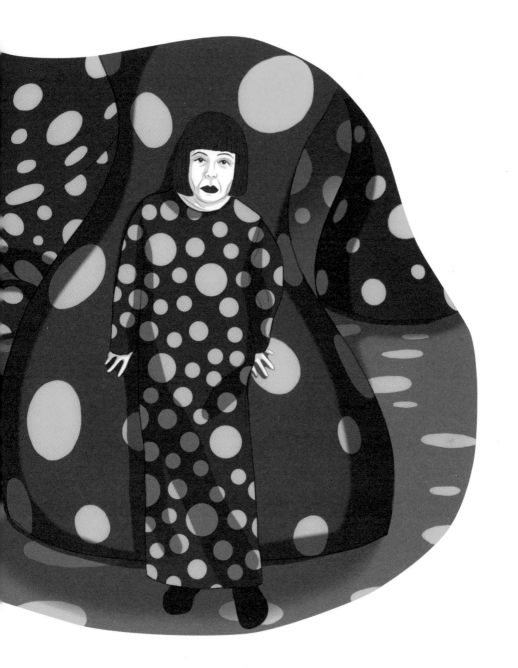

KAZIMIR MALEVICH (1879-1935)

—— AVANT-GARDE ICON

By making the 'supremacy of pure feeling' the sole subject for his paintings, Kazimir Malevich created the vocabulary for all non-representational art. Critics, historians and avant-garde artists still evoke his 1915 *Black Square* painting as art's ground-zero. As the Father of 20th-century Modernism, he remains a perennial cult figure for the creative avant-garde.

Malevich started creating art celebrating the culture of his origins before stripping it to its cleanest forms. His devout Roman Catholic parents had fourteen children, nine of whom survived childhood. His father ran a sugar factory and his mother was active in folk art in modern-day Poland and Ukraine. At the Moscow School of Painting, Sculpture and Architecture, Malevich joined a group of Russian avant-garde artists celebrating folk techniques and traditions. His earliest work contains the style and themes from his upbringing, but when he graduated he shifted towards Cubism. In 1912, he developed a style and philosophy called Suprematism.

As an evolution of Cubism, Suprematism eliminated all traces of representation and featured only pure, strong colours and forms. Freed from signifiers and narratives, Suprematist paintings were honest, direct and intense visual experiences. Circles and squares were Malevich's vocabulary and he used these fundamental forms to express unfettered, universal emotion. He used monochrome paintings to achieve these aspirations, including the first white-on-white canvas in 1918.

Malevich's paintings look cool because he designed them as liberated from politics, manners, social expectations and prejudices. Instead of being based in social structures, Malevich grounded his work in maths. Geometry dictated his imagery. His canvases are populated by rectangles and circles, in single colours, interacting on beautifully basic backgrounds. His compositions have everlasting life and energy. When writing about his work, he anthropomorphised his paintings, speaking of them as representing art's true intentions for itself, instead of humanity's use of art to further an artificial agenda. He believed 'art does not need us, and never did'.

When Stalin gained power, he condemned Malevich for representing elitist, bourgeois values, although Malevich never isolated himself or his work. Malevich brought the accessible ethos he learned from folk art into the lives of his abstract paintings. He collaborated on costumes for operas, illustrated books of poetry, and created the packaging for a chic eau-de-cologne. By focusing on streamlined shapes and paint's primal qualities, Malevich created continuously inspiring art without pretence.

CHRISTIAN MARCLAY (1955)

—— TIMELESS CREATIVE

Christian Marclay is a music nerd. He explores his scholarly approach to music and film in performances, collage, sculpture, photography, installation and video. He has become a cult icon for his magpie sensibility, insatiable intellectual curiosity and playful boundary-crossing. As the defining post-modern visionary, the *New Yorker* described his multi-media creative ethos as 'making something new by lovingly vandalizing something old'. He is beloved for turning overlooked or overseen cultural material into the raw ingredients for poetic, philosophical meditations on his love for music and film. He uses one sense to highlight the beauty and magic of another.

Marclay was born in California, raised in Geneva, educated in New York and now lives mostly in London. His work combines stereotypically Swiss precision, British irreverence and an American's fluency in pop-culture. He is known as a reserved and dignified man, like an opera aficionado who strayed into feral contemporary music cultures. Marclay started his creative life making experimental punk music while splicing and reassembling album covers into unsettling new imagery. A 1991 collage, for example, took slivers of Michael Jackson's face and torso to create legs for a white woman and an African-American woman. He strung together short clips of Hollywood icons talking on telephones, in 1995, for a video montage called *Telephones*. 'The idea of documenting the banal is important to me,' he explained to a reporter for *The Guardian*.

In 2010, he created *The Clock*. This looped twenty-four-hour video montage is his remix masterpiece. It contains moments from *American Gigolo, Breakfast at Tiffany's* and *Columbo* to shots of a watch from *Pulp Fiction*. For three years, he and his assistants picked through movies from mainstream to esoteric. By gathering scenes from film and television for *The Clock*, Marclay synchronised the film with real time, crossing the boundaries between reality and simulacrum. The artwork functions as a working clock. The seamlessly stitched together snippets of time-themed drama flow into a meditation on cinema's influence on our own relationship with ageing and time passing. In some scenes, the passage of time was the theme, with characters panicking or asking each other to check watches. Other clips simply showed a timepiece as backdrop to drama. The watches, clocks, sundials and other measures of time that Marclay cherry-picks from cinema's history earned a cult following among fellow cinephiles, art audiences and anyone conscious of their mortality.

ANA MENDIETA (1948-1985)

—— MYSTICAL GENIUS

For Ana Mendieta, art's greatest value was 'its spiritual role', because she believed art is the 'greatest contribution to the intellectual and moral development of humanity that can be made'. Magic, life, death, belonging and sacrifice were central themes in Mendieta's timelessly mystical art. In her earthworks, she ritualistically merged with her natural surroundings, and her self-portraits included her face covered in blood or a Shenandoah beard. The tragic mystery of her death seems foretold by the violence and outrage in her art. Her cult status among feminist and spiritual artists was earned from early in her horrifically truncated career.

Mendieta was raised in a privileged, cosmopolitan home in Havana but immigrated to the United States after Castro took control of Cuba. Her Catholic girls' school education was an omnipresent influence on her sense of mysticism, although her artwork was more spiritual than religious. Although she incorporated references to the Santerían faith, her art resonates across devotional identities. She started studying art at the prestigious University of Iowa and was deeply connected to the local landscape but was discriminated against for being Cuban. After earning her MFA, she moved to Manhattan and continued making art exposing violence against women and exploring naturalism. In Mendieta's *Silueta Series* (1973–1980), for example, she created prints of her body, often bloodied, in mud, snow and open graves. In one three-minute, Super-8 film *Anima: Silueta de Cohetes* (1976), she set an impression of her body on fire. A 1973 series of slides shows pedestrians ignoring a pile of apparently bloodied clothes. In her film *Burial Pyramid* (1974), she is buried under large rocks with only her head exposed. When she breathes, the rocks appear to rhythmically move, creating the dual impression of her death and life.

Mendieta died in 1985 when she fell thirty-four-floors from her Manhattan apartment, where she lived with her husband, Carl Andre. The minimalist sculptor claimed Mendieta committed suicide over an argument about their relative successes as artists, but generations of artists and activists contest a judicial ruling exonerating Andre from possible manslaughter or murder. Her work is often honoured as a protest against domestic violence. Her reoccurring images of herself wounded or dead are revered as expressions of women's ongoing struggles, and she is among feminist art history's most powerful and poignant figures.

ALICE NEEL (1900–1984)

—— THE REAL DEAL

The people in Alice Neel's deeply human portraits all appear intelligent, sensitive, sexual, warm and wise because portraits are always collaborations between painter and sitter. Neel was a famously empathetic and smart person whose gift for connection infused her art with unique poignancy. Her understated portraits are arguably the greatest of their genre. Before feminism and body positivity fought to empower women with positive self-regard, Neel celebrated female sexuality and women's lived-in bodies through her raw and poetic portraits and self-portraits. She achieved her ambition of creating portraits 'specifically [of] the person and the Zeitgeist'. Her portraits show a sexy boho intellectual group of turtleneck wearers and mothers in slinky mini-dresses but her reality was gritty, raw and ground-breaking.

Born into a middle-class, conservative family in semi-rural Pennsylvania, Neel was the youngest of five children. In her twenties, she began painting in the evenings while supporting her elderly parents with a well-paying clerical job. From the start, her signature expressionistic style evolved from her aesthetic and ideological admiration for the Ashcan School of social realists. The movement's stark honesty and existentialist approach to representation gave Neel a subtle visual vocabulary for expressing themes of anxiety, struggle and loss throughout her artistic career.

Even Neel's sparsest portraits express a keen awareness of loss shaped by her tragic life circumstances. When she was a child, her eldest brother died of diphtheria. Her first daughter also died of the same bacterial infection. When Neel had a second daughter, with her upper-class Cuban husband, he left Neel and took the child to Havana.

Paving the way for social realistic artists like Nan Goldin (see page 65) and Corinne Day, Neel depicted her autobiography through images of people in her life. When

she was living in poverty, she depicted the people close to her with empathy and sensitivity. In the 1930s, Neel was institutionalised in Philadelphia after a suicide attempt and began painting her fellow patients. When she re-entered society, she joined the Works Progress Administration, the US government's New Deal agency for creative professionals during the Great Depression. In this capacity, she chronicled faces of the Socialist resistance and the forgotten members of society who were her friends and lovers. Before she partnered with Sam Brody, a Russian Jewish Marxist intellectual, she was living with a former sailor and heroin addict who set hundreds of her watercolours and paintings on fire. Painful love and grief can be read into her subjects' exhausted bodies and faces.

As a woman, she painted realities of the female experience shunned by male-dominated art. Towards the end of her life, Neel continued to paint herself nude – showing her body with dignity and integrity. While male artists primarily painted women as available, sexually alluring objects, Neel painted tired, strong pregnant and ageing female bodies. Her celebrated *Margaret Evans Pregnant* (1978) shows pregnancy as a fact of life, not a mythic state. Her work still resonates powerfully with female viewers whose phenomenological experience remains rare in art.

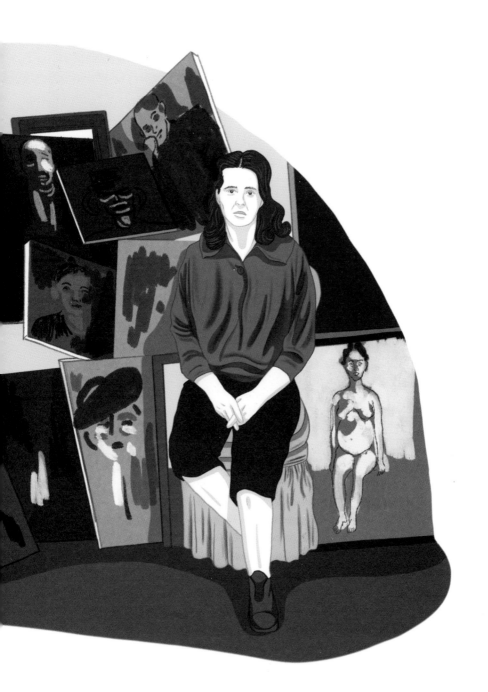

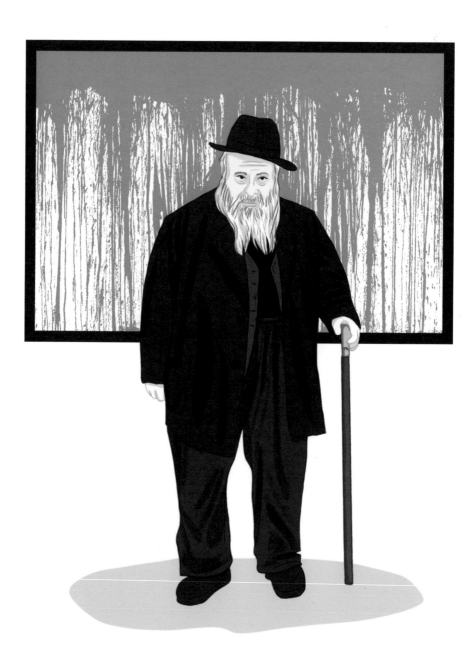

HERMANN NITSCH (1938)

—— BLOODY PROVOCATEUR

Hermann Nitsch bathed 20th-century art in blood. Even his oil-on-canvas *Poured Paintings* from the 1960s can comfortably hang in a torture-porn film-set and/or art gallery. Using only red or brown paint, these massive canvases replicate splattered blood or smeared faeces, evoking madness, chaos, terror and death. Beyond paint, nudity, animal entrails, gutted fish, milk and organ music were Nitsch's other signature materials. His contributions to contemporary culture included a six-day, intoxicated, ritualistic pagan orgy on animal intestines.

For Nitsch, shock was a vital ingredient in his art but not the intended end. Instead of illustrating life, lust and death, Nitsch represented our essential being by bringing these forces, unmitigated, into his art. He brought his audiences into intimate proximity with death and desire. Where Austrian society maintained a polite silence about horror, Nitsch made avoidance impossible. Having experienced World War II as a child, Nitsch was determined to force society to confront its crimes and trauma.

Nitsch was a founding member of the Viennese Actionist movement. Even among the startling performance art movements of the early 1960s and 70s, Nitsch and his contemporaries were uniquely anarchistic. From 1961–1970, they staged actions tearing through placid European conventions and hypocrisies – from religion to fascism and sexual repression. Although Günter Brus, Otto Muehl and Rudolf Schwarzkogler, were never a coherent group or movement according to Nitsch, they shared similar outrages, retaliatory responses, aesthetics and condemnation. They all suffered severe penal consequences for creating controversial performance art. In 1968, Brus was arrested for covering his body in his own faeces and masturbating while singing the Austrian national anthem, and Muehl became a fugitive after his 'Piss Action' performance in Munich. Nitsch was sentenced to three prison terms for 'gross public indecency' throughout his career.

Instead of silencing Nitsch and his peers, authoritative condemnation only demonstrated their art's importance. As the only remaining member of the Viennese Actionists, the contrast between his uncanny physical resemblance to Santa Claus and the bloody bacchanalias he stages adds to his transgressive appeal. In many ways, Nitsch is a genuine Grandfather figure to countless creative subversives. His cult followers include Pussy Riot, Nine Inch Nails, the happy fetishists at Torture Garden and artist Petr Pavlensky who sewed his lips shut to protest Putin. For Nitsch and the generations following his, the shocks he generated are catalytic – jolting society awake to its hypocrisies.

YOKO ONO (1933)

—— AVANT-GARDE OPTIMIST

Yoko Ono created her place in cultural history by countering depravation, scorn and tragedy with extraordinary resilience and messages of love. Her work and identity were shaped by the devastation of war, mental illness, global bullying, loss and grief, yet she made her mark by urging people to say 'yes'. In her art and private life, Ono is a feminist pioneer. During her marriage to John Lennon, she radicalised and revolutionised the role of wives in public consciousness from subordinates to equals: she was Lennon's partner not his muse. Her art continues its influence on all marginalised artists for its fearlessness, nakedness, accessibility and, fundamentally, its optimism.

Ono's parents were an ennobled banker and classical pianist when she was born. Her maternal lineage included samurai warrior-scholars, however, after the Americans firebombed Tokyo, her family was forced to beg on the streets for food before they left Japan for New York. Ono attended Sarah Lawrence College and became influential in Manhattan's avant-garde Downtown art scene before she was diagnosed with clinical depression and institutionalised. Her immobility in her iconic 1963 performance, *Cut Piece*, where she invited audience members to cut off her clothes with scissors, was both an enactment of depression and a statement about women's cultural status. In her art, she often subjects herself to others'

will, enacting the constant combination of vulnerability and resilience that she embodied in her life. Her massive, all-white, chess board, *Play it by Trust* (1966–2011), illustrates the futility of war by creating no distinction between sides, thus eliminating players' conflict.

When Ono met Lennon, he was a fan of her work and she allegedly had no knowledge of him. According to their lore, he visited an exhibition of her conceptual art in London and was captivated by the tiny 'yes' she painted on the ceiling, which viewers only discovered when climbing a ladder and peering through a magnifying glass. Together, they devoted their creative lives to protesting the war in Vietnam and championing social justice advocacy. During their marriage, she was vilified by the global misogynistic, racist media and was kept from contact with her daughter from an earlier marriage. Since Lennon's death, Ono has earned her rightful place in the 20th-century art canon and her influence on artists, feminists, philosophers and other creative thinkers continues to widen and deepen. Her generosity of spirit is evident in artworks like her 2017 installation *My Mommy is Beautiful,* which invited viewers to contribute memories or thoughts of their mothers. Again and again, despite opposition, Ono's greatest legacy might be the word Lennon loved: 'yes'.

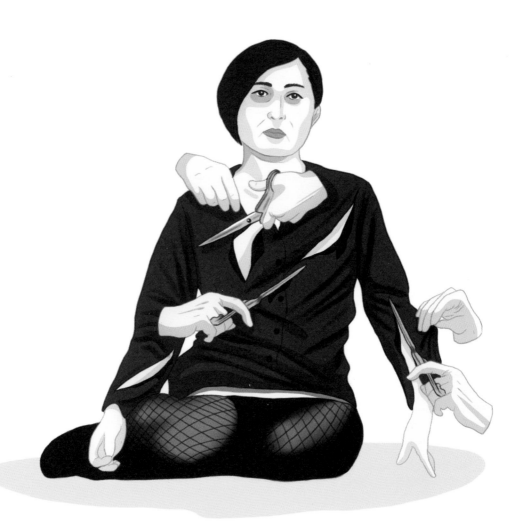

“ REMEMBER, EACH ONE OF US
HAS THE POWER TO CHANGE THE
WORLD. JUST START THINKING PEACE,
AND THE MESSAGE WILL SPREAD
QUICKER THAN YOU THINK. ”

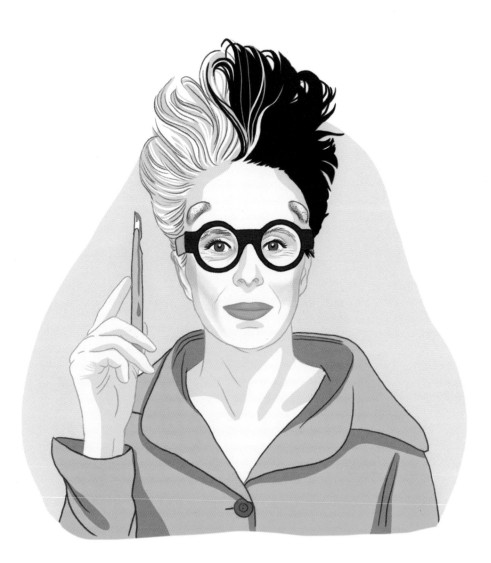

ORLAN (1947)

—— AESTHETIC VISIONARY

Cosmetic surgery is now so mainstream that ORLAN carving her face with a surgeon's scalpel only remains radical because she pioneered the aesthetic and philosophy of today's body modification movement. Even in an era when adolescent Instagram stars mould their appearance and image, ORLAN's thinking and look can still be deeply unsettling. She is like a deity in the body-mod and art worlds.

Mirielle Suzanne Francette Porte was born in the Catholic capital of the Loire Valley and rechristened herself ORLAN at age fifteen. She discovered her own flesh as her medium several years later, through harrowing circumstances. In 1978, she was a pregnant performance and video artist known for blasphemous art. When her pregnancy turned ectopic and required emergency surgery, she opted to remain completely conscious and invited her video crew to tape the procedure. Throughout the process, she viewed the acting surgeon, enveloped in surgical light, as a postmodern priest performing a holy ritual. She interpreted the experience as an invitation to use surgery for her series of physical and conceptual 'rebirths'.

Beauty, art history, sex, gender, carnality, self-harm, feminism and Catholicism are the omnipresent subjects of ORLAN's ever-morphing art practice. She undertook her first cosmetic operation in 1990, on her forty-third birthday, and went on to recreate famous female faces from art history. Instead of experiencing the ecstatic suffering and sacrifice that many ordinary women undergo in adherence to contemporary beauty trends, she enlisted surgeons to give her the nose from a Fontainebleau sculpture of Diana, Boucher's Europa's mouth, Mona Lisa's forehead and the chin of Botticelli's Venus.

The results turn further from the *Real Housewives* with the two curved little horns ORLAN had implanted in her stretched forehead. These silicone protrusions became such a signature that ORLAN sued Lady Gaga in 2016 for forgery after Gaga wore prostatic ridges in her *Born this Way* imagery. The suit backfired, leaving ORLAN responsible for Gaga's legal fees, but her claim that the superstar was guilty of *parasitisme* (the French's charmingly snarky legal term for copy-cattism) is widely agreed upon in the court of public opinion. More than her catchy moniker, her horns (which she often highlights with silver glitter) are her trademark.

A renowned art professor, ORLAN is also widely loved for a less painful look: her massive black and yellow eyeglasses. The glasses, rather than the gore, might represent her best. Although her work is macabre and confrontationally political, ORLAN is beloved for her warmth, humour and shockingly cheerful personality.

GENESIS P-ORRIDGE (1950)

—— POST-GENDER PIONEER

Genesis P-Orridge is best known for being dubbed a 'wrecker of civilisation' by a Conservative member of Parliament while attempting to destroy transphobia, sexual repression and boundaries between creative genres. Identifying themself as a third gender, staging occult performances, fighting for sex worker rights, and birthing the British industrial music and Modern Primitive scenes, earned P-Orridge the purest cult status – where their followers sincerely see them as a possible deity/ subversive shaman. Born, Neil Andrew Megson outside Manchester P-Orridge has been a Grande Dame for transgressive performers, fellow artists (including William Burroughs and Timothy Leary) and people in the broader LGBTQ community since the 1970s. More recently, P-Orridge, whose mantra is 'art as life', has made their existential battle with chronic myelomonocytic leukaemia public, creating aggressively vibrant art in their final days.

In the mid-70s, P-Orridge and counter-culture icon Cosey Fanni Tutti collaborated on the industrial music/avant-garde art/ performance groups COUM Transmissions and Throbbing Gristle. Forming in Kingston Upon Hull, the group grew to define London's most antagonistic creative subcultures. Fanni Tutti, an out and activist sex worker, attracted outrage and support from the British art establishment for her collages incorporating her own work as an adult performer. She pioneered an awareness of sex work as feminist empowerment alongside P-Orridge, who became a champion for transgender and pansexual identities.

P-Orridge continued to be a controversial figure. In 1992, they were enveloped in the trending toxic theory of implanted Satanic ritual abuse memories and accused of running a child sex cult by Channel 4. A police investigation cleared them but reinforced their status as a social scapegoat. They left England for New York, where they met Lady Jaye (nee: Jacqueline Breyer), their wife. She was a statuesque blond dominatrix who called P-Orridge 'Bunny'. The couple were mutually obsessed with each other. Moving beyond partnership, they formed the Pandrogeny Project, which promoted themselves as one fused entity. On their tenth anniversary, they started the process of turning P-Orridge into Jaye through more than $200,000 of concurrent cosmetic surgery. Jointly identifying as Beyer P-Orridge, they got matching breast implants, lip fillers and beauty marks, which P-Orridge continued after Jaye died of stomach cancer at age thirty-eight. At the end of their life, P-Orridge's legacy is being evaluated, with difficult accusations of dominance and cruelty in their relationships, to give them a rightful place in contemporary art's subculture pantheon.

CAROL RAMA (1918–2015)

—— TRIUMPHANT AUTODIDACT

Sex, insanity and death are Carol Rama's central themes. Rama, an autodidact, was completely overlooked until 1980. In 2003, she received a Golden Lion for Lifetime Achievement at the Venice Biennale. Through the integrity of her work, painful subject matter and assent to success, she became a cult figure symbolising visionary art's victory over art-world snobbery. She exemplifies under-appreciated artists' beliefs that time will prove them right and the art world is not a meritocracy. In a 2005 interview, she discussed perceiving the art world as exclusively obsessed with 'beautiful women, prima donnas, beautiful people who speak several different languages sitting and being charming'. Instead, Rama made work from hypodermic syringes, nail polish, sandpaper, leather, human hair and bits of bicycles from her father's shop.

When Rama was a teenager, her family went bankrupt. Shortly after, her mother was institutionalised and her father committed suicide. She struggled with mental health issues throughout her own life and creating art became her coping mechanism. In her early watercolours, she graphically depicts her mother in a hospital bed and beautiful girls in wheelchairs with severed limbs. One watercolour lovingly renders a series of rotten amputated legs. Rama openly represented women as sexual, with tongues out and legs spread. Rama, who remained unmarried, refused to abandon the female body to the male gaze. Her female figures were vulnerable but resilient, and often appeared threatening. In 1945, her first public exhibition was raided by the police and her work was confiscated. In the 1960s, she created a series protesting the Vietnam War called her *Napalm* pictures. These polemic images depicted mutilated bodies using aerosol spray and glass eyes.

Later, she transitioned into a collage-artist. Interweaving text with everyday objects, Rama crafted disarming contrasts of texture, symbolism and content. Many of her pieces utilise rubber salvaged from her father's bike repair shop in Turin. Fixed to plain gessoed canvases to create austere geometric compositions, the beautifully decaying material cracked and thinned like ageing skin. For Rama, art was her protection against her relentless fears and anxieties. Once her work began receiving the recognition it deserved, her release and expression became powerful sources of inspiration for generations of marginalised artists willing to process their private pain into meaningful contributions to humankind's story.

FAITH RINGGOLD (1930)

—— CELEBRATORY STORYTELLER

Faith Ringgold gave African-Americans' lives and voices expression in her beloved narrative quilts. Her artwork looks joyful, relaxed and loving but tells complex tales about historical and ongoing oppression and perseverance. She became a canonised figure in American art history by bringing traditional storytelling techniques into rarefied art-spaces, creating new audiences and platforms for minority expression.

Instead of canvas or paper, Ringgold used a medium specific to feminist and African-American cultural history. She made large narrative quilts, stitching painted canvas with patchwork – combining ancestral sewing methods with contemporary painting techniques – as she merged a folk art aesthetic with sophisticated cultural/ political references. Quilting has an important place in African-American culture because slaves were only given scraps of fabric to create necessary textiles. They used quilting as a way to preserve traditional African designs and often code messages about escape into the fabric. Concurrently, Caucasian women would use quilting circles as opportunities to unify and form early feminist groups. As an artist and activist, Ringgold brought these traditions of support and dissent into the Civil Rights and Women's Liberation movements of the 1950s, 60s and 70s.

Ringgold grew up in the vibrant Harlem arts community, doorsteps away from Duke Ellington and Langston Hughes. Her mother was a fashion designer and her father was a sanitation worker who avidly nurtured his children's creativity. Her art celebrates the support, inspiration and imagination that shaped her upbringing in her home and neighbourhood, while also shining a light on sexism and racism. When she attended City College of New York, women were only allowed to major in Arts Education, not Studio Art, so she trained to become a teacher in the New York public school system and taught until the mid-70s. After she completed a Master's degree in art and left her heroin-addicted first husband, she went on a trip throughout Europe with her mother and two daughters. A visit to the Rijksmuseum in Amsterdam changed her life.

Ringgold's iconic *French Collection* is a witty, touching series of twelve quilts depicting the beautiful fictional life of Willa Marie Simone. Ringgold's alter-ego was a sixteen-year-old Harlem girl who moved to Paris and became a muse for Gertrude Stein, James Baldwin, Langston Hughes, Josephine Baker and other historic outsiders who shaped European and world culture. The whimsy and yearning of her *French* series is replaced by anguish and grief in her 1985/86 *Slave Rape*, but her poetic narratives remain gripping regardless of her tone. The grace, outrage, empathy and warmth evident in her quilts, and her personality, make her art resoundingly influential across age, race, gender and ethnicity.

MARK ROTHKO (1903–1970)

—— TRANSCENDENT COLOURIST

Mark Rothko's abstract paintings are the closest we have to a universal image of the divine. Across faiths, cultures and context, his paintings inspire uncomplicated exultations, awe and profound inner reflection.

Rothko was born Markus Yakovlevich Rothkowitz and was raised a secular Jew in an intellectual household. His pharmacist father was pro-Marxist and passionately atheistic when Rothko was little, but anti-Semitism in Russia created an omnipresent threat for their family. As he grew, his father returned to Orthodox Judaism and Rothko was raised with conflicting, but deeply critical, intellectual traditions. Existential struggle remained a constant source of intellectual and artistic inspiration for him. Rothko and his family arrived at Ellis Island in 1913, where they settled in Oregon and entered the rural working class. An ardent supporter of women's and workers' rights, Rothko aspired to being a union organiser. Instead, he was offered a scholarship to Yale but quickly dropped out and moved to Manhattan. He was absorbed into New York's tight-knit avant-garde art community of Abstract Expressionists through the city's gritty bar and studio scene.

Rothko's early representational surrealist paintings were dreamy, soft and reminiscent of urban Impressionists like Bonnard and Walter Sickert. In the late 1940s, Rothko developed the 'multi-form' colour block paintings that became his legacy. In these works, he painted with oils on massive canvases, keeping colours separate but letting the edges bleed, creating a sense of unity and harmony between forms. The simple, consistent patterns let colours and paint assert their emotional power. The canvases' size created an immersive experience for viewers.

Throughout the 1950s, Rothko's fame escalated but he feared his collectors were commodifying his art without understanding. He despised the affluence, oppression, social hypocrisies and cruelties of his collectors yet continued to create art. In 1967, he was commissioned by the de Menil family to create a chapel in Texas. It was conceived as a non-denominational pilgrimage destination with Rothko's transcendent paintings as the sole visual statement. After completing the Chapel, he was diagnosed with heart issues. His problematic drinking and nicotine addiction, combined with depression, kept him from looking after his failing health. He left his wife and children to become a recluse. At age sixty-six, Rothko committed suicide in his kitchen without a note.

The spiritual fulfilment viewers feel from his work did not relieve Rothko of his private pain and torment, but his art is regarded with reverence and he retains cult status, for creating uniquely simple but emotionally resonant art.

MARK RYDEN (1963)

—— SUBCULTURAL SURREALIST

Mark Ryden is a quintessential cult icon. He is a treasured eccentric whose devoted fan base idolises his witty, spooky, masterfully made oil paintings. He combines wonky weirdness with masterful execution to celebrate oddities, cross boundaries and to challenge taste. The Pop Surrealism movement that he founded alongside his wife, Marion Peck, is a subculture adjacent to the art world. Instead of what is lauded in scholarly magazines, high-end galleries and auction houses, Ryden's and Peck's world is occupied by pin-up girls, Goths, alienated intellectuals and other wonderful misfits.

Ryden's work is defined by his renegade relationship with music and pop culture. Having graduated from the Art Center College of Art and Design in Pasadena, he became a defining figure in the Los Angeles gritty, dark, urban subculture scene. In contrast with LA's bubbly, sunny mainstream and its art community's preference for austere conceptualism, he brought humour and quirkiness to the West Coast. He started his career designing dreamscapes for album covers for Michael Jackson, the Red Hot Chili Peppers, Aerosmith and other bands. Katy Perry, the subject of a portrait by Ryden, is an avid fan of his art. In a soulmate merger, he designed book covers for Stephen King but he's also created costumes and sets for the American Ballet Theatre.

Ryden's signature subjects are girls with porcelain doll faces and babyish proportions in cryptic settings and sinister situations. He loves using meat as a motif, dressing his girls in elaborate gowns constructed from raw flesh. Whatever their context, his characters are blasé, with a Buster Keaton-esque 'Stone Face' – massive but unreadable eyes. Adding to his work's unnerving allure are his pastel palette and high-gloss surfaces. Ornately baroque frames are connected parts of his art, not afterthoughts, creating a B-movie-style faux antiquity. In the paintings themselves, Ryden draws heavily on Rococo aesthetics while depicting Leonardo DiCaprio (another of Ryden's admirers), Abraham Lincoln, the Teletubbies and Jesus serenading a trio of jaded blond baby-dolls.

Expanding beyond their canvases, the homes and studios shared by Ryden and Peck in Los Angeles and Portland, are elaborate *cabinet-de-curiosités*, where they gather orphaned collectables and flea-market treasures. While their work's embrace of camp and kitsch alienates art-world taste-makers, they remain an uncommonly welcoming and friendly force. With their unquestionable talent but strangeness, they draw wider audiences into the art's weirdness.

CAROLEE SCHNEEMANN (1939–2019)

—— FEMINIST PERFORMANCE ICON

Carolee Schneemann was a pioneer in nude feminist performance, and primarily used her own body to demonstrate how women could reclaim the female form from centuries of objectification. She drew from various vanguard media and suppressed histories to create a groundbreaking vision of female-focused artistic creativity. As a cult figure, Schneemann is almost deified by artists seeking a higher understanding of how marginalised bodies can assert and celebrate their identities. Her oeuvre is a source of inspiration for taboo-busting visionaries from Pussy Riot to Lady Gaga.

In 1964, Schneemann staged *Meat Joy*, a performance/orgy in which male and female dancers gleefully interacted with raw fish, poultry and sausages, as well as fresh paint and ropes, while laughing. Whereas the Viennese Actionists orchestrated their orgies to spotlight life's chaotic frenzy, Schneemann's bacchanalian performance was designed as a homage to life-affirming pagan rites. Although her pleasure-positive intention did not stop a male audience member from trying to strangle her before two well-heeled Parisian women intervened.

For Schneemann, raw meat was not a taboo medium. She was raised on a farm. Because her father was a country doctor, she was familiar with the cycles of birth and death on an atavistic, pragmatic level. Although she was raised to become a country wife, she was offered a full scholarship to attend Bard College in New York state. In her junior year, she was expelled for 'moral turpitude'. Bard never fully explained the expulsion, but Schneemann believed her drawings of her own naked body, with her legs open, scandalised the famously liberal faculty. For her, nudity and sexuality were part of life and she refused to repress or suppress the realities of women's bodies. She finished her

studies in Manhattan at the New School and Columbia University.

Interior Scroll, Schneemann's 1975 performance, perhaps best demonstrated her dedication to bringing women's own experiences of their bodies into an art context, instead of only representing men's idealised impressions of women. For the performance, whose fame and infamy Schneemann feared would eclipse her total oeuvre, she stood nude on a table and pulled a long paper scroll out of her vagina like a tampon and read its contents. A photograph taken at the performance of her naked body and anti-pin-up-girl pose is one of the 20th century's most iconic art images. In that image, and all her work, Schneemann's body and her artistic voice were defiantly her own.

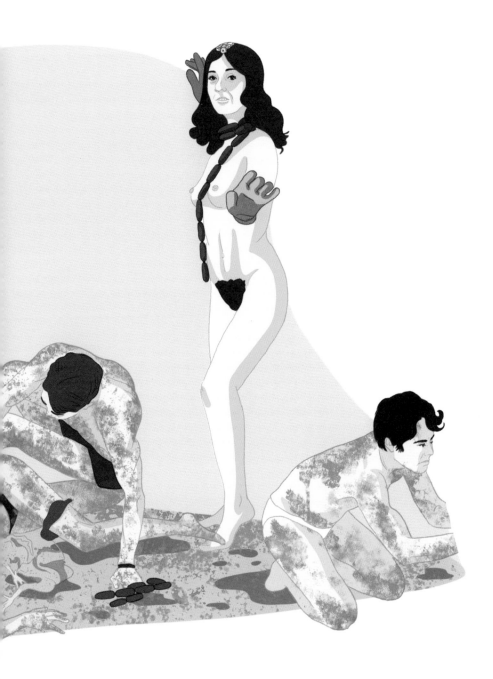

YINKA SHONIBARE (1962)

—— POST-COLONIAL CRITIC

Yinka Shonibare's captivating artwork, grounded in his identity as a Nigerian-British artist, explores the relationship between contemporary globalism and histories of colonialism. Shonibare was born in London. His family returned to Nigeria when he was three but moved back to London in his late-teens. As a member of the culture-changing Young British Artists (YBAs), he garnered widespread admiration for his signature use of 'African' fabrics bought in Brixton's markets. By tracing and exposing the complex webs of influence comprising these fabrics' remarkable visual impact, Shonibare inspired a deep re-evaluation of history and heritage in England. For Shonibare, the idea of being monocultural is always a myth.

During Shonibare's time as a student at Central Saint Martins School of Art and Design, then Goldsmiths University of London, he developed his distinctive vernacular by investigating the history of the batik fabrics he bought for himself. Although these printed textiles were perceived as traditionally African by mainstream English culture, as Shonibare unearthed, they were actually first manufactured in Europe for sale in Indonesia and then resold in Africa. Mining the fabrics' history led Shonibare to discover the Africanised fabrics' contemporary sources are mostly based in the Netherlands and England. He began using these fabrics to replace canvas, as the base for paintings, before conceptualising elaborate Rococo-style costumes for figures to wear in sculptures and installations. The tableaux that Shonibare designs replicate historical costume exhibitions, playfully re-writing European history to incorporate these cross-cultural artefacts. In 1998, he recreated Thomas Gainsborough's *Mr and Mrs Andrews* painting with headless mannequins (their attentive dog kept his head) dressed in a vibrant abundance of fabric.

Shonibare's satirical use of museology as his medium is partially inspired by his physical challenges as a disabled artist. Shonibare contracted transverse myelitis, a rare neurological condition creating spinal inflammation, when he was eighteen. Paralysis leaves him reliant on assistants to execute his work. While most highly established artists employ assistants, his inability to create his own work means he became a 'curator' for a museum of alternative history. Alongside being an artist, he is an advocate for the disabled community – writing about his perceptions and experiences for newspapers and magazines – and supporter of charities for London's homeless. In 2004, his cult status as a pioneer of post-colonialist critique was evidenced when he was shortlisted for the Turner Prize. He lost but was voted the people's favourite.

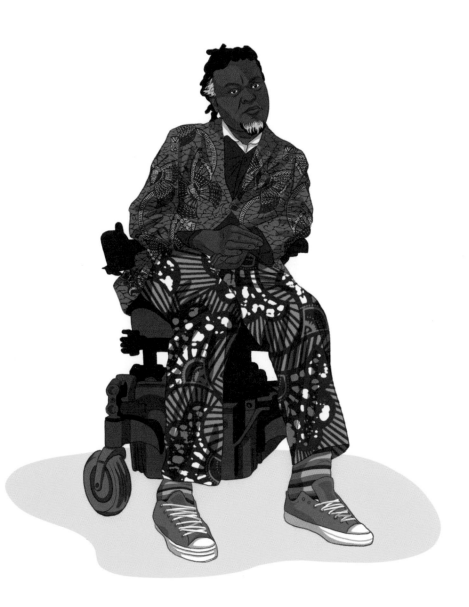

MALICK SIDIBÉ (1936–2016)

—— CHRONICLER OF COOL

Malick Sidibé drew global audiences to the panache of Malian youth culture in the 1960s. He is a cult figure for fashion photographers, designers, artists and cool kids for bringing African style to audiences in his evergreen images. Sidibé's influence can be seen in endless homages by top international fashion photographers from Steve Meisel to Maxime Ballesteros. In his black and white portraits of *Africans for Africans*, Sidibé used glamour and charisma as tools of resistance against the restrictive, patronising, post-colonialist gaze. He guided his captivating subjects to use their beauty and cool to re-define Africa for the world.

Sidibé was born in the Yanfolila district of Mali, in a small village. Sidibé, ironically, was denied access into the family business because problems with his eyesight made joining the family's cattle-farm impossible. When his father died young, Sidibé was sent to school where educators selected him for the prestigious School of Sudanese Artisans. A book of paintings by Eugène Delacroix, a prize he was given in school, became a life-long source of aesthetic inspiration. Once in school, he started his artistic journey making jewellery but was enlisted by revered society photographer Gérard Guillat to decorate his studio. Guillat adopted Sidibé as an apprentice. Using a camera borrowed from Guillat, Sidibé started to photograph nightlife in Bamako after finishing work. He photographed the high-end Zazous kids' Parisian fashions and the DIY swagger of Mali's Yé-yé, the less affluent teenagers who organised 'dust dances'. The people in Sidibé's images appear completely themselves, although he was meticulous when directing poses and structuring his images. The images of dance parties and clubs, as well as people posing in his studio, are as fresh and crisp as anything exposing today's youth culture.

Rock music was the central protagonist in Sidibé's images. Society in Mali was radically changing in the 1960s. Independence transformed society, but the most significant shifts were caused by American rock becoming accessible. Sidibé's image of two smiling teenage girls twisting together while holding a James Brown record between them, like a shared lover, defined the spirit and ethos of his era. The cultural revolution was wild but not chaotic, an energy he articulated through his subjects and studio practices. Motorbikes, sunglasses, women in trousers and men in suits, populated his photographs – creating an omnipresent, always enviable, party atmosphere.

STELARC (1946)

—— CORPOREAL INNOVATOR

For Stelarc, human bodies are a malleable medium. As a champion of cyborgisation, Stelarc is a cult figure for cyborg activists, bio-hackers, members of the body modification community, sci-fic fanatics and top-tier universities who recognise his art as heralding a new age of 'post-human' creativity. The Cypriot-Australian performance artist, born Stelios Arcadiou, uses medical imagery, robotics, music, prosthesis and surgical modification to morph into creations that test the boundaries of our reality.

In 2007, he had a human ear, cultivated from his living cells, surgically constructed on his left forearm (since his head was deemed too dangerous). The operation was inspired by an artificial ear that Harvard and MIT professors grafted onto the Vacanti mouse in 1996. For this experiment, a laboratory mouse had a human ear grown on his back using cartilage. Stelarc went further by employing medical professionals to make an ear that he describes as 'a remote listening device for people in other places'. His plan was to insert a wireless microphone into the ear, to broadcast his life to listeners across the world.

The ear Stelarc attached to his arm was an oddly natural progression from the physical challenges he engineered for himself in the 70s and 80s. He doesn't reveal much about his childhood in Melbourne but his earliest work included bringing suspension art – the reason-defying act of suspending the body in the air using giant fish-hooks through the skin – into galleries across four continents. In 2012, at age sixty-six, he repeated the feat in Sydney, incorporating his extreme pain into his conceptual process as sixteen shark-hooks lifted him above a massive sculpture. His intention was to transcend the pain and become a human beyond his physical thresholds. For his *Partial Head* sculpture, he scanned his face and used his own tissue to create a partially living self-portrait before it became contaminated with microbesafter a week.

By pushing beyond his physical being, Stelarc has been feted with honorary doctorates, exclusive academic fellowships and awards. He was appointed an honorary professor of Art and Robotics at Carnegie Mellon University. Like fellow body-modification pioneers ORLAN (see page 109) and Genesis P-Orridge (see page 110), Stelarc is especially remarkable for the contrast between his extreme vision and warm, accessible, public personality. Interviews and videos with him present a friendly, engaging, intellectually curious nerd whose enthusiasm for radical self-sacrifice originates from a joy in life's wonders and possibilities.

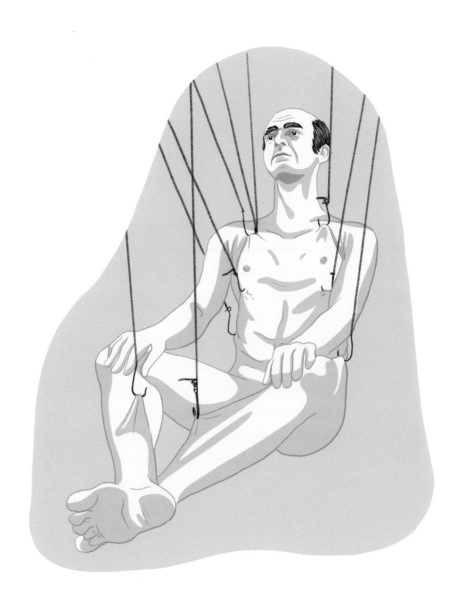

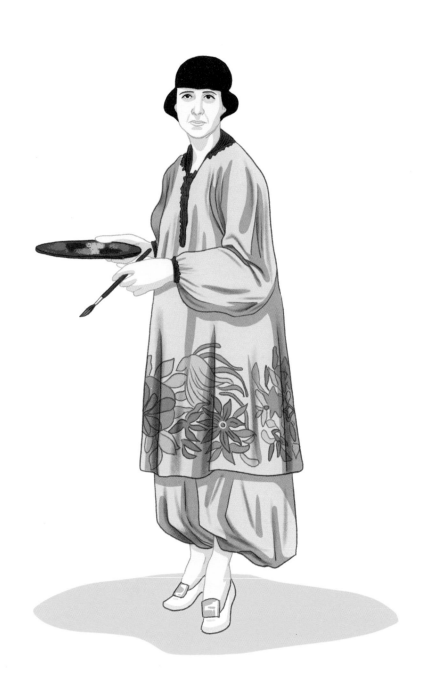

FLORINE STETTHEIMER (1871-1944)

—— SOCIAL UTOPIAN

Florine Stettheimer painted her lavish, elegant oil paintings in the early 20th century but she remains a thoroughly modern woman. She was an empowered sex-positive feminist who celebrated all genders and envisioned a world of effortless racial harmony. Instead of striving to combat social injustice with strident imagery, she painted seductive scenes of an alternative universe without prejudice and discord while subtly mocking her social class's pretention and prejudices.

Stettheimer and her sisters were celebrated beauties who could have drifted through their lives as pampered socialites. Wealthy German-Jewish girls raised in Rochester, New York, they were collectively known in social circles as the 'Stetties' but they were the anti-Kardashians. Instead of partying and marrying wealthy men, the sisters devoted themselves to a pastoral lifestyle, travel and artistic achievements. After their father left the family, the girls and their mother saw themselves as an ideal Amazonian collective. They were, in today's terminology, woke. Alongside creating their own artworks, the sisters hosted a ground-breaking salon for 'for contemporary literati, gay and polyglot New Yorkers and European expatriates', regularly attended by Georgia O'Keeffe and Marcel Duchamp (see page 48).

Stettheimer's own canvases were sprinkled with light-hearted touches of magical realism. Her slim oeuvre of precious watercolours and paintings had a faux-naïve aesthetic contrasted with her cultural sophistication. *Asbury Park South*, Stettheimer's 1920 oil painting, broke barriers and represented the Jazz Era through its depiction of slinky African-American and Caucasian families relaxing and revelling together on a then-segregated New Jersey beach. She used a luscious and lovely palette to convey joy and whimsy. A self-portrait shows herself sitting against a tree in a loose white trouser suit, red lipstick and matching heels. She holds a messy palette and dirty brush while gazing into the distance, deep in thought. Tucked behind the tree is an androgynous, mythic figure – probably her muse – hiding millimetres away from her touch.

Stettheimer was known for her captivating charisma and quick wit. Another self-portrait showcased her progressive sexual self-confidence and humour. For her 1915 *A Model (Nude Self-Portrait),* she became a pioneering example of a woman artist refusing to be a muse and claiming her body, and sexuality, as her own by presenting herself in the posture of Manet's infamous *Olympia* (1863). Although Stettheimer remains a niche icon, her admirers resurface in times of political turbulence and contention because she presents an alternative to assumptions about political artists and protest art. In today's divisive era, Stettheimer's pure joy is almost revolutionary.

KARA WALKER (1969)

—— CHRONICLER OF AMERICA'S PREJUDICE

Kara Walker used the most monochrome of media to explore and challenge America's history of racial atrocity. Curators, critics, art audiences, activists and the Smithsonian Museum revere her brutally biting gallows humour and fearlessness when confronting America's ongoing injustices. She tore into the myth of a colour-blind America by resurrecting silhouettes, a bygone medium from the Victorian era. Using this forgotten art form, Walker drew attention to America's perennial abuse of African-Americans.

Walker's wall-sized cut-paper silhouettes garnered critical attention when she was a graduate student at the prestigious Rhode Island School of Design. Before RISD, Walker studied art in Atlanta, where her father taught at Georgia State University. Moving to the American South as an adolescent shaped her consciousness and creative trajectory. When Walker was a child, she lived with her parents in a progressive, multi-cultural, creative community in California. Her father was an accomplished painter and her mother was a costume designer. When Walker was growing up, she aspired to become a cartoonist. Once her family relocated to southern America when Walker was thirteen, she became subject to explicit racism from her classmates and realised her experiences in California were the exception for most Americans.

Walker's panoramic friezes tell the story of slavery in Antebellum South using gothic magic-realism. Silhouettes were traditionally used for genteel portraiture and children's book illustrations in the Victorian era. Walker, instead, used the medium for elaborate and intricate visions of the rape, abuse, misery and cruelty endured by slaves. In 2014, she used an even more saccharine medium to depict historical horror and make it relevant. She crafted a sphinx, dressed as a stereotypical Southern Mammy, using over 70 tonnes of sugar cubes donated by the Domino Sugar company for installation in Brooklyn's 132-year-old historic Domino factory, before the building was demolished. She titled the enormous sculpture and its accompanying sugar figures, *A Subtlety: The Marvellous Sugar Baby, an Homage to the unpaid and overworked Artisans who have refined our Sweet tastes from the cane fields to the Kitchens of the New World.*

Walker was not the first artist to use piercing irony to revisit and reclaim history, but her work's combination of aesthetic elegance and unflinching confrontation makes her a cult figure for political artists. As a faculty professor at Columbia University, Walker pushed the influential MFA program towards greater involvement in surrounding social issues, but her greatest contribution to contemporary art is making political work that isn't didactic. It is engaging and dynamic but still teaches vital lessons about historical atrocities, ongoing injustices and art's ability to enlighten.

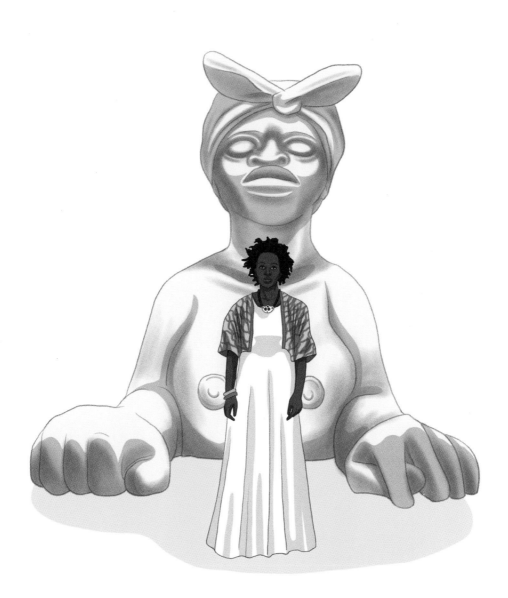

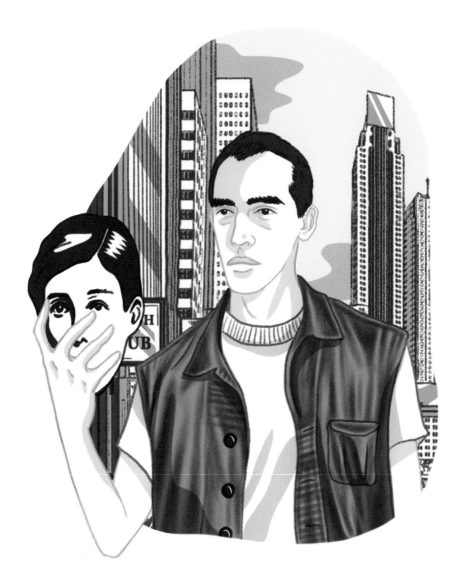

DAVID WOJNAROWICZ (1954–1992)

—— POP-CULTURAL PROTESTER

David Wojnarowicz was a painter, sculptor, photographer, film-maker, writer and warrior. When he was diagnosed as HIV-positive, his illness became his subject and medium. As Wojnarowicz wrote, 'When I was told that I'd contracted this virus it didn't take me long to realize that I'd contracted a diseased society, as well,' and he used his art to fight the sicknesses of prejudice, injustice and repression. The image of his lips sewn shut in Rosa von Praunheim's 1989 film *Silence = Death* is one of the most iconic and powerful moments in 20th-century culture.

A former homeless teen hustler, Wojnarowicz grew up victim to childhood abuse. Despite his harrowing challenges, he graduated from a prestigious Manhattan public school for gifted youths and became the axis of New York's rough avant-garde. He and his tribe of fellow creative outlaws were politically engaged and frequently vilified by political conservatives and religious fundamentalists. Alongside artists like Nan Goldin (see page 65), Peter Hujar, Jean-Michel Basquiat (see page 14), Richard Kern and Karen Finley, Wojnarowicz's pop-culture savvy and confrontational art represented painting's aesthetic in the 1980s. His group of artists fought against the increasingly market-driven art world by producing art for the street. He didn't see his art as precious but intended it for public consumption and contemplation. For *Rimbaud in New York*

(1978–79), he simply wore a mask of the poet's face in diners, the subway and Times Square while Hujar photographed him in black and white. The resulting images are playful but oddly poignant.

In 1987, Hujar, his long-time friend and lover, died of AIDS and Wojnarowicz documented his emaciated body in brutal portraits. He learned of his own HIV-positive diagnosis shortly after Hujar died. Both tragedies propelled him into furious activism. His sense of urgency fuelled his work about AIDS. During the AIDS epidemic, President Reagan and fellow Republicans were outwardly vocal about believing AIDS victims deserved to die. The people with total power withheld funding and care from gay men and drug addicts, whose lives were deemed disposable, or worse. Wojnarowicz used his own fading body, as well as their own words, to demonstrate the homicidal horror of the government's neglect. In this context, the image of him sewing his mouth shut became the defining piece of art about the AIDS crisis.

Four years after his death from AIDS in 1992, Wojnarowicz's friends followed his wishes, as written in his 1991 memoir *Close to the Knives,* and scattered his ashes on the White House lawn. His legacy is that all artists yearning to understand how art can contribute to societal change still look to Wojnarowicz's example.

KEY WORKS

Dan Attoe
Forgiveness (2007)
It's All The Same (2007)
Full Moon Over the Plains (2012)
Complicated Animals (2014)
It'll be OK (2016)
The Sound of the Falls (2017)

Balthus
The Guitar Lesson (1934)
Girl and Cat (1937)
Thérèse Dreaming (1938)
The Victim (1939–1946)
Sleeping Girl (1943)

Jean-Michel Basquiat
Ernok (1982)
Red Rabbit (1982)
Untitled (Fallen Angel) (1983)
Boxer Rebellion (1983)
Riding with Death (1988)

Joseph Beuys
Fat Felt Sculpture (Fat Battery) (1963)
How to Explain Pictures to a Dead Hare (1964)
The Sled (1969)
Felt Suit (1970)
We are the Revolution (1972)
I Like America and America Likes Me (1974)

Christian Boltanski
Monument (1987)
Favorite Objects (1988)
The Reserve of Dead Swiss (1990)
Humans (1994)
Eyes (2013)

Louise Bourgeois
Femme Maison (1946–1947)
Fillette (1968)
Janus Fleuri (1968)
Maman (1999)
Untitled (Couples) (2001)

Leigh Bowery
Session I, Look 2 (1988)
Session II, Look 10 (1989)
Session III, Look 15 (1990)
Session IV, Look 21 (1991)
Session VII, Look 39 (1994)

Chris Burden
Five day Locker Piece (1971)
Shoot (1971)
Trans-fixed (1974)
Beam Drop (1984/2008)
When Robots Rule (1998)

Sophie Calle

Suite Vénitienne (1980)

The Hotel, Room 47 (1981)

Address Book (1983)

The Divorce (1992)

The Wedding Dress (2010)

Chapman Brothers

The Disasters of War (1993)

Fuck Face (1994)

Cockroach Kid (1997)

The Rape of Creativity (2003)

Insult to Injury (2004)

Judy Chicago

Heaven is for White Men only (1973)

The Dinner Party (1979)

International Honor Quilt (1980)

Earth Birth (1983)

Power Headache (1984)

The Creation (1984)

Joseph Cornell

Rose Hobart (1936)

Palace (1943)

Untitled (Penny Arcade Portrait of Lauren Bacall)
(1945–1946)

Planet Set, Tête Etoilée, Giuditta Pasta (1950)

Untitled (Celestial Navigation) (1956-58)

Molly Crabapple

Week in Hell (2012)

Shell Game (2013)

Syrian Girl Scarred by Barrel Bomb (2014)

Kim Boekbinder (2016)

Illustration for *Whores but Organised* (2019)

Salvador Dalí

The Persistence of Memory (1931)

Autumnal Cannibalism (1936)

Swans Reflecting Elephants (1937)

Dream Caused by the Flight of a Bee
Around a Pomegranate a Second
Before Awakening (1944)

Melting Watch (1954)

Portrait of Gala with Rhinocerotic
Attributes (1954)

Niki de Saint Phalle

Shooting Picture (1961)

Hon (1966)

La Fontaine Stravinsky (1983)

The Tarot Garden (1998)

Les Trois Grâces (1999)

Marcel Duchamp

Nude Descending a Staircase (1912)

Prelude to a Broken Arm (1915)

Fountain (1917)

L.H.O.O.Q. (1919)

Dust Breeding (1920)

El Anatsui

Erosion (1992)
Old Man's Cloth (2003)
Bleeding Takari II (2007)
Blood of Sweat (2015)
Second Wave (2019)

James Ensor

Tribulations of Saint Anthony (1887)
Christ's Entry into Brussels in 1889 (1888)
Belgium in the XIXth Century or King Dindon (1889)
Skeletons Warming Themselves (1889)
The Skeleton Painter (1896)
Self-Portrait with Masks (1899)

H. R. Giger

Friedrich Kuhn (1973)
Penis Landscape (1973)
Li II (1974)
Necronom IV (1974)
Artwork for *Dune* (1975)

Gilbert & George

Singing Sculpture (1969)
Human Bondage series (1974)
Dirty Words Pictures (1977)
Spunk Blood Piss Shit Spit (1996)
Fury (2011)

Guerrilla Girls

The Advantages of Being a Woman Artist (1988)
Do Women Have to be Naked to Get in the
 Met Museum? (1989)
When Racism and Sexism Are No Longer
 Fashionable, How Much Will Your Art
 Collection Be Worth? (1989)
Guerrilla Girls' Pop Quiz (1990)

Nan Goldin

Greer and Robert on the Bed, NYC (1982)
Nan One Month After Being Battered (1984)
The Ballad of Sexual Dependency (1985)
Sisters, Saints & Sibyls (2006)
Protest Against Oxycontin (2018)

Jenny Holzer

Truisms (1984)
In a Dream You Saw a Way to Survive
 and You Were Full of Joy (1984)
First Impressions (1989)
Red Yellow Looming (2004)
Protect Protect (2007)

Donna Huanca

Raw Material (2013)
Melanocytes/Etheric Layer (2016)
Scar Cymbals (2016)
Silicone Mother (Blond) (2016)
Surrogate Painteen (2016)

Dorothy Iannone

A Cookbook (1969)
I Am Whoever You Want Me To Be (1970)
Wiggle Your Ass For Me (1970)
Play It Again (2007)
I Lift my Lamp Beside the Golden Door (2014)

Frida Kahlo

My Birth (1932)

My Nurse and I (1937)

The Two Fridas (1939)

Self-Portrait with Cropped Hair (1940)

Self-Portrait with Monkey (1940)

The Broken Column (1944)

Allan Kaprow

Baby (1957)

Yard (1961)

Oranges Hanging by Strings (1964)

Untitled (Calling) (1965)

Spring Happening (1969)

Mike Kelley

The Banana Man (1983)

More Love Hours Than Can Ever be Repaid (1987)

Pay For Your Pleasure (1988)

Arena #7 (1990)

Craft Morphology Flow Chart (1991)

Extracurricular Activity
 Projective Reconstruction (1995)

Yves Klein

Monotone Symphony (1949)

Untitled Blue Sponge Sculpture (SE 180) (1957)

Anthropometry (1960)

Blue Venus (1960)

International Klein Blue (IKB) (1960)

Barbara Kruger

Untitled (Talk Is Cheap) (1985)

I Shop Therefore I Am (1987)

Untitled (Your Body is a Battleground) (1989)

Who Owns What? (2012)

Untitled (Know Nothing, Believe Anything,
 Forget Everything) (2014)

Yayoi Kusama

Untitled (1966)

Watching the Sea (1989)

Pumpkin (1999)

Dots Obsession (2003)

Infinity Nets (2014)

All The Eternal Love I Have for the Pumpkins (2016)

Kazimir Malevich

The Knifegrinder Principle of Glittering (1912–13)

An English Man in Moscow (1914)

Black Square (1915)

Supremus No 55 (1916)

Suprematist Composition: White on White (1918)

Black Circle (1923)

Christian Marclay

Record Without a Cover (1985)

Body Mix series (1991)

Telephones (1995)

The Clock (2010)

Untitled, Cassette Tape Duplication (No. 15)
 (2012)

Ana Mendieta

Untitled (Facial Hair Transplants) (1972)
Silueta Series (1973–1980)
Burial Pyramid (1974)
Butterfly (1975)
Anima (1976)

Alice Neel

Well Baby Clinic (1928)
Ethel Ashton (1930)
Dominican Boys on 108th Street (1955)
Ginny in Striped Shirt (1969)
Margaret Evans Pregnant (1978)
Self Portrait (1980)

Hermann Nitsch

Blood Picture (1962)
Poured Painting (1963)
Golden Love (1974)
53rd Action (1976)
Schüttbild (75th Painting Action) (2017)

Yoko Ono

Cut Piece (1963)
Grapefruit (1964)
Ceiling Painting (1966)
Play it by Trust (1966–2011)
Glass Hammer (1967)
My Mommy is Beautiful (2017)

Orlan

Reincarnation of Saint Orlan (1990)
Omnipresence (1993)
Refiguration/Self-Hybridation no. 2 (1998)
AUGMENT (app) (2011–ongoing)

Genesis P-Orridge

It's that Time of the Month (From Tampax
 Romana) (1975)
The Pandrogeny Project (2003–2007)

Carol Rama

Appassionata (Marta e i marchettoni) (1939)
I Due Pini (1941)
Bricolages (1966–67)
La Guerra E' Astratta (1969)
Nuove Seduzioni (1985)

Faith Ringgold

Who's Afraid of Aunt Jemima? (1983)
Slave Rape series (1984–85)
French Collection series (1991)
Tar Beach (1991)
Jo Baker's Birthday (1993)

Mark Rothko

Archaic Idol (1945)
Violet Center (1955)
Orange and Yellow (1956)
Four Darks in Red (1958)
Red on Maroon (1959)

Mark Ryden

Inside Sue (1997)
Fur Girl (2009)
The Piano Player (2010)
Memory Lane #104 (2013)
Anatomia (2014)

Carolee Schneemann

Personae: JT and Three Kitch's (1957)
Eye Body: 36 Transformative Actions (1963)
Meat Joy (1964)
Interior Scroll (1975)

Yinka Shonibare

Mr and Mrs Andrews Without Their Heads (1998)
Scramble for Africa (2003)
Nelson's Ship in a Bottle (2010)
Cheeky Little Astronomer (2013)
Woman Shooting Cherry Blossoms (2019)

Malick Sidibé
Regardez-moi (1962)
Nuit de Noël (Happy-club) (1963)
Fans de James Brown (1965)
Untitled (1976)
Un Jeune Gentleman (1978)

Stelarc

Suspension series (1980)
Partial Head (2006)
Ear On Arm (2007–ongoing)

Florine Stettheimer

A Model (Nude Self-Portrait) (1915)
Self-portrait with Palette (1915)
Asbury Park South (1920)
Spring Sale at Bendel's (1921)
The Cathedrals of Broadway (1929)

Kara Walker

The Renaissance Society installation (1997)
The Emancipation Approximation (1999–2000)
Darkytown Rebellion (2001)
Grub for Sharks: A Concession
 to the Negro Populace (2004)
A Subtlety (2014)

David Wojnarowicz

Rimbaud in New York (1978-79)
Untitled (Falling Man and Map of USA) (1982)
Self-Portrait of David Wojnarowicz (1983–1984)
A Fire in My Belly (1986–87)
Untitled (Desire) (1988)
Untitled (Time/Money) (1988)

INDEX

To my parents

—

Ana Finel Honigman is a New York-born
art and fashion writer with a Doctorate
degree in the History of Art from Oxford
University. She lives in Berlin and
Baltimore. Alongside her academic work,
Ana has written about contemporary
art and fashion for magazines including
ArtNews, *Artforum.com*, *British Vogue*,
Dazed & Confused, *Frieze*, *Guardian
Unlimited*, *Texte Zurich Kunst*, *New York
Times* and *Wall Street Journal*.

Kristelle Rodeia is a freelance illustrator
based in Paris. After studying Plastic Arts
and Graphic Design, she is now a full
time illustrator working in a mixture of
pen, ink and digital drawings. Previous
clients include *Stylist*, Veneta Bottega
and *Erratum*.

Brimming with creative inspiration, how-to projects and
useful information to enrich your everyday life, Quarto
Knows is a favourite destination for those pursuing their
interests and passions. Visit our site and dig deeper with
our books into your area of interest: Quarto Creates,
Quarto Cooks, Quarto Homes, Quarto Lives, Quarto
Drives, Quarto Explores, Quarto Gifts, or Quarto Kids.

First published in 2019 by
White Lion Publishing,
an imprint of The Quarto Group.
The Old Brewery, 6 Blundell Street,
London, N7 9BH,
United Kingdom
T (0)20 7700 6700
www.QuartoKnows.com

Every effort has been made to trace the
copyright holders of material quoted
in this book. If application is made in
writing to the publisher, any omissions
will be included in future editions.

A catalogue record for this book is
available from the British Library.

ISBN 978 0 71124 029 2
Ebook ISBN 978 0 71124 612 6

10 9 8 7 6 5 4 3 2 1

Illustrations by Kristelle Rodeia

Printed in China